What on EARTH is HEAVEN like?

What on EARTH is HEAVEN like?

What on Earth is Heaven Like?
© 2011 Janet Willis
All Rights Reserved

Printed in the United States of America

ISBN: 978-1-935507-49-9

Illustrations by Janet Willis
Cover Design & Page Layout by David Siglin of A&E Media
Edited by Kacie Dalton

AMBASSADOR INTERNATIONAL
Emerald House
427 Wade Hampton Blvd.
Greenville, SC 29609, USA

AMBASSADOR BOOKS
The Mount
2 Woodstock Link
Belfast, BT6 8DD, Northern Ireland, UK

www.ambassador-international.com
The colophon is a trademark of Ambassador

Patti M. Hummel
President & Agent
THE BENCHMARK GROUP LLC, Nashville, TN
www.benchmarkgrouppublishers.com

IN MEMORY OF THE B TEAM
Ben, Joe, Sam, Hank, Elizabeth, & Pete

The last got to be first.

ENDORSEMENTS

JANET HAS BROUGHT TOGETHER THE heart of one passionate for truth, the skill of an able student of the Word, and the keen eye and hand of an artist. After a thorough search and study of each of the passages in the Bible that deal with the future City of God, Janet has collated those Scriptures into a systematic theology of what Scripture itself says about the future city. The result is a unique examination of the details that are too often overlooked by people in their search for a description of the future. Her commitment to propositional revelation and the consistent interpretation of the Scriptures in both the Old and New Testaments brings the assurance of a study based on biblical facts. But then as a skilled artist she is able to give us a portrait of what those details may look like. Looking at her careful illustrations, one sees, often for the first time, a rendering of what the Scriptures themselves describe. It is at once comprehensible, stunning, and changes your entire perspective about the eternal city. As I now read in God's Word about the eternal city, I am finally "able to imagine it."

Janet's work is thorough without being overly technical, making it accessible to anyone who wants to be a better student or teacher of the Bible. She has done the church a wonderful service.

DAVID L. BURGGRAFF, PH.D.
Professor of Theology
Shepherds Theological Seminary
Cary, NC

JANET WILLIS HAS TAKEN A very difficult and little discussed topic, presenting it accurately and in a way that we all can understand and visualize. We had read Randy Alcorn's book on Heaven, and think *What on Earth is Heaven Like?* has taken our understanding of the beauty and glory of the New Jerusalem a step further. Her artwork shows great skill and understanding of Scripture.

May all be blessed who study this book, and may it send us to the Book of Books to study Scripture like the Bereans! May this book encourage us all to be prepared for His glorious appearing!

DR. RONALD A. ALLCHIN, SR.
Executive Director
Biblical Counseling Center, Arlington Heights IL

JANET WILLIS IS A CHRISTIAN mother on a mission. For familial reasons that are profoundly deep, Janet is driven to present to the Christian public an authentic vision of the eternal state that is thoroughly biblical, richly theological, genuinely empirical, and, via her marvelous skill in art, visually majesterial.

For many of us who embrace the Christian faith, most medieval depictions of heaven appear as fanciful and fictional distortions of its realities. Janet's work is designed to rescue us from these fabrications and falsehoods. This has led her to engage in a meticulous research of the biblical data which relate to heaven. Having embraced what scholars would call a literal/normal hermeneutic, which takes seriously what Scripture actually says about the world to come, she has managed to give us a perspective of heaven that goes beyond the abstract to the concrete. The eternal state will be nothing less (and perhaps infinitely more) than a full restoration of Edenic conditions on planet earth. Janet makes the indisputable, biblical point that it will possess the same literal properties and spiritual presence that Adam and Eve enjoyed in the original Eden – this time never to be lost again.

It is no small task to articulate with clarity these realities, whether verbally with words, or visually in art, but Janet has managed to do both. I have no doubt that *What on Earth is Heaven Like?* will be a rich source of comfort, encouragement, and edification to all of us who anticipate the realities of heaven, and long to join our loved ones who have preceded us there.

DOUGLAS R. MCLACHLAN
Chancellor, Central Baptist Theological Seminary
Plymouth, MN

BOOKSTORES ARE CLUTTERED WITH MATERIAL about heaven. Children and grownups have written bestsellers about their brief journey there and back again. But nearly all of their descriptions have little to do with the actual truths about the glory of God and the beauty of the Father's House. Janet's careful research into the actual, biblical descriptions of heaven will take you step by step, verse by verse, exposing truths that most Christians have never heard before – including the fact that the heavenly city will one day be on earth. Sound surprising? Well then, buckle up as your Biblical tour is about to begin. Take it directly from me, very few books have so profoundly challenged and changed my thinking. And best of all, this book left me with deeper gratitude for my coming Lord as well as greater anticipation for the amazing future home he's prepared for those who love Him. You'll finish this book and more than likely say the same thing I did – "I can hardly wait!"

STEPHEN DAVEY, SENIOR PASTOR
Colonial Baptist Church, Cary, NC

HOW TREMENDOUSLY ENCOURAGING TO READ and reread *What on Earth is Heaven Like?* by my friend Janet Willis. She is and has been a student of the Word for the many years I have know her. (My first encounter with her was so many years ago as a pastor's wife who called Biblical Counseling Center to be sure the counseling she was giving women in their church lined up perfectly with Scripture!) It has been so encouraging to me and to many others to see her grow through tragedy, to stand for Truth in the midst of painful trials. Her quest led to a calibrated study of every reference in Scripture that would shed light on what her beloved children now experience and what all of us who love Jesus will one day experience. Her excitement about Heaven is evident as you read her insights and study her artwork. She is a gifted artist, as well as a clear voice for communicating Biblical truth.

Because I am a visual learner, *What on Earth is Heaven Like?* has opened my eyes afresh to the beauty and reality of Heaven. It gave me a new level of hope and understanding that in the end, God will make all things right. I feel strengthened for what is ahead, prepared to face difficult times with confidence that Heaven is coming! Janet was able to portray the New Jerusalem as real, a place we long to call Home.

I believe this book meets a need in our culture for a renewed excitement about His glorious appearing. It will surely become a classic in its own right, an encouragement to all who read and study what Janet Willis has written and illustrated.

SHERRY ALLCHIN, M.A.
Counselor/Teacher/Editor

COMPELLED BY FAMILY TRAGEDY OF indescribable agony, Janet Willis began a careful, detailed, and clear study of what we can know about heaven. The result is a landmark work that offers clear, real hope to those who are suffering now and to all of us whose suffering is ahead. The author is a easy-to-read and thorough writer. Her illustrations reveal an accomplished artist with a love for truth and the Bible. I strongly recommend this unique and powerful book!

WALT BROWN
Author of *In the Beginning: Compelling Evidence for Creation and the Flood*

TABLE OF CONTENTS

FOREWORD

EVERY NOW AND THEN YOU read a book that transforms your worldview and causes you to have fresh insight into familiar Scriptures. This book by Janet is such a study.

For years I have made it my life mission to study the life of Christ. I have worked hard to properly understand Christ's life and message. Over 70 times Jesus made reference to the Kingdom... preaching, "repent for the Kingdom of heaven is near" (Matthew 4:17). In my studies, I have tried often to creatively imagine the conversations Jesus had with His disciples in Acts 1:3b when it says, "He appeared to them over a period of forty days and spoke about the Kingdom of God."

After working carefully through Janet's material over the last few months... I have found a deepened love for wanting to go even deeper in understanding that message of His Kingdom! I feel I have a much better understanding of Jesus' Kingdom message and His Kingdom vision.

Janet in this book has painted (by words and pictures) a look into Christ's future Kingdom in a way that can transform your life. When I first was exposed to her work... I questioned it the way I question any fresh insight into God's Word. I opened my Bible and began to study.

While none of us can say that we have fully mastered God's future dealings with His people, Janet's study will enlarge your grasp of Scripture. I have found this study to be fresh, challenging, and incredibly exciting. I have found myself again and again going over these passages of Scripture to glean new insight. I have found myself eager for His coming Kingdom... telling many others about it. I have found myself concluding that it is very real, very tangible, and will be experienced fully by all of us who love His appearing.

Having led several tours to Israel, this book has caused me to fall in love again with God's plan for His people. Each time I step into the present day Jerusalem... I find myself longing in a deep way for that Heavenly Jerusalem, that Janet works so hard to biblically discern in this book. Whether you fully agree with her conclusions or not, I know that this study will deepen your love and longing for His return.

I'd encourage you to read these pages with an open heart... asking God to speak to you through His Words. I'm sure you will agree with me that Janet has worked hard to understand the teaching of Scriptures. Janet loves the Word, loves the Lord, and is a fellow student of Scripture. May you find this study as exciting and fresh as I have... enlarging your view of His coming Kingdom.

DR. DANN SPADER
President of Global Youth Initiative

Main Scripture Passages

THE MAIN SECTIONS OF SCRIPTURE that will be discussed in this study are listed below in order that the reader may examine what God has to say in the full context. The summaries highlight connections to the future that is promised by God.

GENESIS 1–2

God creates the earth and the first people. He places them in a paradise where He walks with them in fellowship face to face.

GENESIS 3

The first two people rebel against God and lose the privilege of that close relationship. God promises that a Redeemer will come someday, One who will restore that which was lost.

GENESIS 15

God tells a man named Abraham that the Redeemer will be one of his descendants. God gives Abraham an unconditional promise of a land that will extend from the River of Egypt to the Euphrates. Abraham believes God's word.

PSALM 2

Kings of the earth will fight against God's Redeemer, but God will eventually set Him up as King upon His holy mountain.

PSALM 46

Someday, the earth will undergo great and frightening changes. We are encouraged to picture God in the midst of His city, to think about His great power, and to remember His promise of final victory over evil.

PSALM 48

Someday, God's city will bring great joy to the earth. However, some will feel terror and anguish when they see it. The beauty and the strength of it reflect His character.

ISAIAH 2

God tells us that someday geological changes will make "the mountain of the house of the LORD" the highest point on earth. He reveals the sequence of end time events, gives reasons for His Judgment, and describes how various people will react to these events.

ISAIAH 4

God gives details about His future Kingdom. After the Judgment, He will create a special protective canopy over the whole area of Mt. Zion.

ISAIAH 11

God tells us the qualities of the future King and more details about His future Kingdom. There will be peace and safety in His holy mountain and "His resting place will be glorious."

ISAIAH 24–27

God reveals a detailed account of His timetable for end time events. In the midst of this account, God mentions a special mountain where there will be no more death.

ISAIAH 35

In relation to specific locations in Israel, God paints a picture of beauty, healing, and joy, giving physical details of His Kingdom to come.

ISAIAH 49

God not only tells us of His purpose to bless and restore the whole world through Israel and the people He has chosen, but He also relates specific ways that He will do this.

ISAIAH 52

God promises to restore Jerusalem.

ISAIAH 60, 62, 65, 66

God comforts His people and shows His proactive love by giving descriptions of His future capital city, Jerusalem.

JEREMIAH 30–31

God declares that His heart yearns for His people. He says they will repent and He will have mercy on them. He will gather them as a shepherd gathers his flock. He will bring them to the land He promised them, and their city will again exist on the site of its ruin.

JEREMIAH 32:36–33:26

God sharpens the focus on Jerusalem and its surrounding area. Many specific details show that fulfillment of these promises are still future.

EZEKIEL 40–48

God gives the entire layout of Israel's future Kingdom capital. Specific locations are designated for each tribe, a temple, surrounding homes for the priests, and "a structure like a city."

DANIEL 2:44

When God sets up His Kingdom, He will put an end to all other kingdoms, and His Kingdom will endure forever.

JOEL 3:14–21

God gives again the end times timetable, saying that He will dwell in Zion and that Jerusalem will be holy and inhabited forever.

MICAH 4

God repeats His end times timetable (from Isaiah 2) and says that He will reign over His people in Mount Zion forever.

MICAH 7:7–20

God says He will show His unchanging love to Abraham, and Israel's land will extend from Egypt to the Euphrates.

ZECHARIAH 2

God says He will dwell in the midst of His people in Jerusalem.

ZECHARIAH 8

God says again that He will dwell in Jerusalem and many peoples and mighty nations will come to seek Him there.

ZECHARIAH 14

God says someday the geography of Israel will be changed, but Jerusalem will exist "on its site." The city will have no more curse.

LUKE 1:31–33

When Jesus sets up His Kingdom, it will have no end.

JOHN 14:1–3

Jesus refers to His Father's house in heaven as already existing and connects it in relation to His return to earth.

ROMANS 11

Although God punishes Israel, they are still His beloved. Because of His unconditional promise to Abraham, eventually Israel as a nation will turn to the Lord. They will be grafted in again and experience the fulfillment of all that God promised to Abraham.

HEBREWS 11:8–10, 16

We learn that when Abraham was still on earth, he was looking forward to dwelling in the city made by God. Other heroes of the faith also had that focus.

HEBREWS 12:18–26

Mt. Sinai is contrasted with the heavenly Jerusalem. Mt. Sinai is where God met with His assembled people on earth, and the heavenly Jerusalem is where God presently dwells with "the general assembly and church of the firstborn." God then specifically compares how He shook the earth when He appeared at Mt. Sinai to how He will shake heaven and earth when He appears to set up His unshakable Kingdom. He quotes Haggai 2:6, whose context gives details of His future earthly Kingdom capital.

REVELATION 4 AND 5

God showed John His throne and what surrounds it in heaven.

REVELATION 20–22

God showed John more details about end time events and their timetable. He also showed John a close-up view of the New Jerusalem and His throne. God renews the earth to its original condition and again dwells with His people. He told John to write down the details in order to comfort and encourage us.

For the joy set before Him, (He)
endured the cross Hebrews 12:2

INTRODUCTION

FEW HAVE THE PRIVILEGE THAT I had, growing up in an authentic, honest-to-goodness home sweet home. There were six of us growing up, and as the fourth of six children, I was blest to be in the midst of all the fun. Dad designed our big two-story Cape Cod, gradually finishing off the second-floor bedrooms with his own hands. Mom taught us valuable lessons. Once, when I was about six, she dragged one of our lightweight bunk bed mattresses to the top of the stairs, sat on it, pulled up the front like a toboggan, and slid down the stairs. We all had our turns at the wild, bumpy ride, laughing so hard we cried. Looking back, I think Mom actually enjoyed us!

Many years later, God allowed me to have the joy of being a mom, graciously giving my husband and me nine children. Lots of laughter echoed in our home too. By 1994, our oldest three were married and starting their own families, and I was busy homeschooling our youngest six. Then on November 8 of that year, we had an accident beyond our worst nightmare. Our van hit a piece of road debris, causing the gas tank to explode, resulting in the deaths of our six youngest children. At the very accident scene, knowing the God of the Bible was vital. I knew that God loved my children and that He loved me as well. I also knew God was sovereign. For those who love the Lord, there is actually no such thing as an accident. And I had already learned about the long view of life. As I wrestled with indescribable horror and shock, truths from His Word kept me sane. I realized those first moments of my loss were their first moments of great gain. They were entering the very gates of heaven. My youngest six were going to enjoy everything a mother would ever want for her children. They were going to be happy, they were going to be safe, and they were going to be good, forever.

In the days and weeks that followed, our once bustling, boisterous home was far too quiet. I desperately drank in God's Word. Now, more than ever before, details about heaven just jumped off the page. I was amazed how much the Bible revealed about the ultimate home sweet home, my Father's home in heaven. I was not just looking for comfort; I wanted truth. Continuing a pattern I had begun before our accident, I wrote the references down in a notebook, along with a few of my thoughts. Now that I had more time, I began to look back over my notes, wanting to review, compare, and piece together related passages. I soon realized I needed to write out the verses in order to do this kind of study.

After about twelve years, I had so many notes about heaven and the future God has in store for us I decided that, rather than read through the Bible, I would organize my notes and do an in-depth study of these topics. I had learned so many new things. I began to think my first words when I reach heaven will

be, "But … this is so real!" I started with a focus on my children, but gently and wisely God changed my focus. As I learned more about what eternity is really going to be like, I gained a greater understanding of God's own goodness.

But of course, as I found answers, new questions surfaced as well. Besides digging into the Bible, I read lots of other books on the subject of heaven. I noticed that modern authors talked mostly about the spiritual aspects of heaven, which is of utmost importance and which was a great blessing to me personally.[1] However, most authors said very little about heaven's physical characteristics, especially God's heavenly city, the New Jerusalem. Older books freely dealt with both. I noticed this same change in the words of songs down through the years. Since God gave us so much information concerning the physical details of this city, I wondered why these were no longer discussed.

What caught my interest most, however, was the scarcity of artwork done on the New Jerusalem throughout history. Illustrations of other biblical subjects abound in museums and books around the world. Every time I did find a picture of the New Jerusalem, I would be grateful that someone had made an attempt. Nevertheless, as I would study what was drawn, I couldn't help but think, "They weren't taking into consideration this verse or that verse." Either artistic license ruled or the illustrator didn't know the Scriptures, and it bothered me. My own love of art made my fingers itch to try to do better. But what if someday someone looked at my own artistic attempt and said, "But she forgot about this verse or that verse!"

With the goal of eventually illustrating what I was reading in the Bible, I had to hang on to every word. My husband, a retired pastor, encouraged me and showed me how to use his library of resources and do inductive Bible study. I consulted commentaries and was grateful for the scholarly research and hard work of others. As my personal quest developed, I sought advice from respected theologians. Throughout my investigation, I found a great deal of agreement among those who took a literal approach to Bible interpretation. However, when it came to prophecy, they sometimes disagreed with one another. In fact, it has been said, "Even the best of prophecy scholars and experts disagree on how to interpret the biblical doctrine of the New Jerusalem."[2] While I realized I had a responsibility before God to seek truth, I had no idea where my search would take me. Eventually, the main conclusions I arrived at were not expected. In fact, I struggled with them. Continuing to search, I found not only encouragement but confirmation from my advisors and the Scriptures. Although I am committed to rightly dividing the Word, I do not claim to have perfectly accomplished that. I present this work only as a proposed interpretation.

To the reader who might be unfamiliar with the Bible, or to one who simply wants to know more about where I am coming from, I encourage reading the section called "An Invitation"

at the end of this study. To the reader who is familiar with the Bible, I share below the principles of Bible interpretation that I have attempted to follow:

1. All Scripture is to be understood in its most natural, normal sense, allowing for figures of speech.
2. Context is key.
3. Compare Scripture with Scripture, including all relevant passages. Let related clear passages lead in interpreting difficult passages.
4. Assume that God's Word will not contradict itself.
5. Recognize that prophetic passages sometimes have both near and far fulfillments, with our guidelines being the principles given above.

Ultimately, I ask the reader to understand that I have approached this subject as an artist. I can identify with artists in the past who have faced some unique challenges illustrating biblical events. When Jesus appeared after His resurrection, He looked quite normal. No halos or supernatural glow alerted people of His divinity. On the other hand, the illustrator had to somehow convey to the viewer which man was Jesus. Maybe this is a clue of just how earthy and real the New Jerusalem will be. Thus, in attempting to portray a perceivable place, I run the risk of causing the viewer to be underwhelmed. In addition, I also realize that though a picture is worth a thousand words, when it comes to the Bible, art is merely a vehicle. My main goal then is that my artwork might motivate the reader to listen carefully to the words of the Comforter who comforted me.

Blessed be the God and Father of our Lord Jesus Christ, the Father of mercies and God of all comfort, who comforts us in all our affliction so that we will be able to comfort those who are in any affliction with the comfort with which we ourselves are comforted by God.
II Corinthians 1:3–4

I have always known that I will never have certainty about the New Jerusalem's appearance until I see it with my own eyes. My intention is to somehow convey our future home to be a tangible, concrete reality. May my feeble attempts stir up others who can do better.

Adversity in some form will come into everyone's life eventually. My desire is that this look into the future will either give a clear and real hope to those who are presently suffering or that it might help prepare those whose suffering is still ahead. Years ago Romanian Christians shared a saying with one another as they suffered great persecution and poverty under an oppressive dictator: "*Every believer ought to have a chance to go to America at least once before they go to heaven, so the shock won't be so great.*" Many Americans don't realize the taste of heaven we enjoy. We don't hunger for heaven. We're not ready for adversity. For those who don't have that hunger,

may this work wet your appetite. For those who do have that hunger, may His words grow your faith. May His promises display His love for you.

Now, lest my emphasis on the material aspects of a Christian's glorious future make us lose sight of the One who makes it all possible, we need to picture this scene. Thousands upon thousands of angels every single day actually get to see the Golden City, idyllic Paradise, and of course God's very throne. Ironically, while we might be here on earth longing to see what they see, they might be using their free time to study all about the marvelous truths of the great salvation given to us by Jesus Christ (I Peter 1:12).

I am deeply grateful to all those who helped to make *What On Earth is Heaven Like?* a reality. I thank each of you for your faithful prayers and I thank the Lord for the answers to those prayers. I thank Him for the burden He placed on my heart and for His grace that helped me do something about that burden. I am thankful for the multitude of counselors he sent my way, however in the end, I must accept responsibility for the result. Patti Hummel, thank you for your wisdom, careful attention to detail, and balance. Thank you to the team at Ambassador International: Sam, Tim, David, Kacie, and all those who worked to bring this project to fruition. Thank you, Ron and Sherry Allchin, Walt and Peggy Brown, Darlene Anderson, and Bob Mulloy for your time and your encouragement: Dave Burggraff, your willingness to give my early attempts a serious examination gave me great courage; Stephen Davey, thank you for teaching your own congregation ideas discovered in this quest; Doug McLachlan, your careful but kind critique is invaluable. Thank you Charles Cooper for the long hours you spent pouring over my findings, and then graciously allowing me to grill you over the phone with my questions. Dann and Char Spader, it was your excitement about the Kingdom that spurred me on. Thank you, Dann, for actually putting my early study into print. Laurie Paschen, thank you for your precious hunger to learn about heaven, and Kim Willis for your penetrating questions. They were a great motivation. Thank you, Sue Vejvoda, for your patient listening ear and wise counsel. Thank you, Amy, Toby, and Dan, for more tough questions and for supporting your mother. What precious joy you are! Most of all I thank my gifted pastor teacher, my toughest critic, and best friend, Scott. I am looking forward to a happily ever after with you.

chapter one
OUT OF HIS GREAT LOVE

BOX OFFICE SMASH HITS, BEST sellers, and TV preachers have taught millions about the bad news, the coming Judgment of the world. But is this all there is? After Armageddon is there no happy ending? Deep in every human heart, hope for some sort of happy ending has flickered at some time or another. Archeology gives evidence from cultures around the world and down through the ages that humans have had a sense of eternity. Something exists beyond this life. The Bible boldly claims it is God who has put eternity in our hearts (Ecclesiastes 3:11), and He reveals to us a great deal about what that eternity will be like.

> But, as it is written, "What no eye has seen, nor ear heard, nor the heart of man imagined, what God has prepared for those who love him."—these things God has revealed to us through the Spirit. For the Spirit searches everything, even the depths of God.
> I Corinthians 2:9–10 (ESV)

Things that the eye will eventually see, God has described in imaginable detail. In other words, all that He wants us to know about our future with Him has already been revealed through the Spirit, through the prophets, through the Bible. And through these very details, God reveals Himself. He shows us the depth of His compassion, the height of His power, the breath of His great love. Our Maker knows our frame; He knows we are but dust. He knows we need a clear and real hope, the kind of hope that will help us endure the great tests of life. God graciously gives us the privilege of looking through His telescope, giving us the long view.

As the Bible opens its panorama of history, God begins a general pattern of directing our thoughts to the future. The first two chapters of the Bible divulge a profound story of paradise given, paradise lost, and a prophecy that points to that paradise restored. God placed the first two people that He made in a garden in Eden. In that place of security, harmony, and beauty, God walked among them and met with them face to face. However, rebellion resulted in tragic separation—banishment from that place of blessing. Then God revealed a promise. A Redeemer would come and right the wrong (Genesis 3:15). Then throughout the Old Testament, God slowly unveils details of not just a happy ending but a happily ever after. Prophecies progressively spell out descriptions of that Redeemer's magnificent future Kingdom. First to Adam and Eve, then to the patriarch Abraham, to King David, and to the prophets we can follow

this progression. God gradually sharpens the focus on the cen-terpiece of this Kingdom, His exquisite capital city, the New Jerusalem. We know that Abraham had some knowledge of this city beyond what is related to us in the Genesis account, "for he was looking for the city which has foundations, whose architect and builder is God" (Hebrews 11:10). And still others …

> … *died in faith, without receiving the promises, but having seen them and having welcomed them from a distance, and having confessed that they were strangers and exiles on the earth. For those who say such things make it clear that they are seeking a country of their own. And indeed if they had been thinking of that country from which they went out, they would have had opportunity to return. But as it is, they desire a better country, that is, a heavenly one. Therefore God is not ashamed to be called their God; for He has prepared a city for them.* Hebrews 11:13–16

As we move on to the New Testament, we see how the prom-ised Redeemer, Jesus Christ, entered our world. He continued the kingdom theme. While He was here on earth, Jesus men-tioned the Kingdom often, almost 50 times just in the book of Matthew alone. He taught us to pray to God the Father, opening with "Thy kingdom come" and closing with "for Thine is the kingdom" (Matthew 6:10–13 KJV). But ultimately, He came into our world to pay the penalty for our sin. The night before He died, Jesus' concern was for His followers. Tenderly He prepared them for the severe trials that lay ahead.

> *"Do not let your heart be troubled.… In My Father's house are many dwelling places; if it were not so, I would have told you; for I go to prepare a place for you."*
> John 14:1a, 2

God's home apparently includes many dwelling places, a city! John was a young man when he heard those words that night. Many years later, as an old man, he had the privilege of seeing a vision of that city. "And I saw the holy city, new Jerusalem" (Rev-elation 21:2). Eventually, after he died, he came to that city …

> … *to Mount Zion and to the city of the living God, the heavenly Jerusalem, and to myriads of angels, to the gen-eral assembly and church of the firstborn who are enrolled in heaven, and to God, the Judge of all, and to the spirits of the righteous made perfect, and to Jesus, the mediator of a new covenant, and to the sprinkled blood, which speaks better than the blood of Abel.*
> Hebrews 12:22–24

However, that is not the end of the story. That is not the happy ending. When John was still alive on earth and saw that vision, he not only saw the New Jerusalem, but he saw it "coming down out of heaven from God" (Revelation 21:2). Likewise,

when the Lord said He would go and prepare a place for His followers in His Father's house, He finished that thought by saying, "If I go and prepare a place for you, I will come again and receive you to Myself, that where I am, there you may be also" (John 14:3). When the Lord comes back, He is bringing His house with Him. The heavenly city will someday land here on this earth.

That is why this biblical song predicts that the city of God will someday be the joy of the whole earth:

> *Great is the LORD, and greatly to be praised, in the city of our God, His holy mountain. Beautiful in elevation, the joy of the whole earth, is Mount Zion in the far north, the city of the great King. … Walk about Zion and go around her; count her towers; consider her ramparts; go through her palaces, that you may tell it to the next generation. For such is God, our God forever and ever; He will guide us until death.*
> Psalm 48:1–2, 12–14

Mt. Zion, the city of the great King, is Jerusalem. The songwriter encourages us to focus on the physical details of a real structure, things that we can picture. As we try to imagine the city, the song concludes with "such is God" (v. 14). God's city shows us what God is like. Attributes of this future Jerusalem reveal attributes of God. Out of His great love, He will actually come to live with us. And out of this city, God will give joy to the world forever and ever.

Here a word of explanation is in order. This work is an attempt to collect and organize any verses that might concern the future home that God has promised us. Many Old Testament prophecies concerning Jerusalem or Mt. Zion appear to have a possible far fulfillment, as well as one that is near. If a passage could possibly and reasonably point to a far fulfillment, it was included, just to see where it would lead. Information was collected following a pattern of connecting the dots, so to speak (i.e., If A=B, and B=C, then A=C). Thus, depending on context, terms such as *the throne of God, Mt. Zion,* and *Jerusalem*, etc., were linked together. The entire process was similar to assembling a giant jigsaw puzzle, without the benefit of seeing the lid. Separate categories such as the location, the size, and the shape of the city are each interrelated with the aspect of the timing of its appearance. Eventually when the puzzle is fully assembled, a cohesive picture becomes evident. Taking a fresh look at the issue of size produced a major breakthrough. Suddenly many puzzle pieces fell into place.

This work will attempt to give evidence for the following conclusions:

1. The New Jerusalem already exists in heaven and is God's home.
2. When the sky rolls back as a scroll (Revelation 6:12–17), Jesus Christ and the New Jerusalem will appear in the sky.

3. God will begin to judge the world and pour out His wrath. The earth's surface will undergo drastic destruction, along with great topographical changes.

4. When God's wrath is finished, He will renovate the earth's surface.

5. The New Jerusalem will actually land on earth at the beginning of Christ's Kingdom.

6. It will be the capital city of the Kingdom.

7. The first thousand years of the Kingdom will have unique characteristics.

8. At the end of the thousand years, Satan and those who follow him will surround the area of the capital city then be destroyed.

9. After God's final Judgment (Revelation 20:11–15), His Kingdom on earth will continue for eternity.

Christ often admonished the people of His day for their lack of faith in the truths that had already been revealed: "And He said to them, 'O foolish men and slow of heart to believe in all that the prophets have spoken!'" (Luke 24:25); "'If I told you earthly things and you do not believe, how will you believe if I tell you heavenly things?'" (John 3:12). This error should not be repeated, especially since Christ's first coming has already provided for us a consistent pattern of literal fulfillment (Isaiah 53, Psalm 22). The Lord's rebuke compels us to plunge forward, to follow every cross reference, every clue, every trail.

Throughout the Bible, God gives us numerous word pictures of His future Kingdom's capital city. On one hand, some of these beg to be drawn. On the other hand, it seems an impossible task for anyone to get it right. It's like trying to visualize a blueprint described with only words or an x-ray described in a written medical report. Nevertheless, the more information we know about our future home, the easier it is to picture it. And the easier it is to picture it, the easier it is to focus on it. For this reason, artwork is included in this study as an attempt to illustrate some biblically-based possibilities. In the following passage, we are told not only to focus but also to set our affections on this heavenly abode of Christ.

If ye then be risen with Christ, seek those things which are above, where Christ sitteth on the right hand of God. Set your affection on things above, not on things on the earth.
Colossians 3:1–2 (KJV)

Therefore, as we now embark upon this exploration, the songwriter David gives us an exhortation. He assumes that future inhabitants of the New Jerusalem will be familiar with all that God has revealed. God's character is demonstrated by God's acts, both in the past as well as in the future. It's the details, the specifics that are critical. A spontaneous and bold witness to others will result.

[Thy saints] shall speak of the glory of Your kingdom and talk of Your power; to make known to the sons of men Your mighty acts and the glory of the majesty of Your kingdom. Your kingdom is an everlasting kingdom, and Your dominion endures throughout all generations. Psalm 145:11–13

Fear not, for I have redeemed you;
I have called you by name, you are mine...
because you are precious in my eyes and
honored, and I love you

ISAIAH 43:1, 4 ESV

YOUR KINGDOM COME, YOUR WILL BE DONE
ON EARTH AS IT IS IN HEAVEN.
MATTHEW 6:10-13 (KJV)

LOCATION, LOCATION, LOCATION

JERUSALEM: THE CITY OF PEACE

PRESENT–DAY JERUSALEM DEFIES THE MEANING of its name. The City of Peace is the most fought-over piece of real estate on earth. Tensions concerning this parcel of land could bring us to the brink of world war. For thousands of years, Jewish families around the world have ended their annual commemoration of Passover with the declaration, "Next year in Jerusalem!" "O Jerusalem, Jerusalem," Jesus said, "the city that kills the prophets and stones those sent to her! How often I wanted to gather your children together, just as a hen gathers her brood under her wings, and you would not have it!" (Luke 13:34). What is it about this city that sets it apart from all others?

The term *Jerusalem* is used over 600 times in the Bible. However, there are many other names for the city, such as *the city of God, the mountain of the Lord, the Holy City,* and of course *Zion.* Sometimes these names refer to what was then present-day Jerusalem, sometimes they refer to heavenly Jerusalem, and sometimes they refer to a future Jerusalem on earth. A further complication is that these terms are also occasionally used as a metonymy, describing the main part of the city, or the entire mountain on which the city sits. The terms *Jerusalem* and *Zion* can even be used in a general sense to mean the people of Israel (Isaiah 51:16–17). Even today we use place names in similar ways. For example, when we speak of the city of Chicago, we might mean the downtown area, the official city limits, or the greater metropolitan area including the suburbs. We also sometimes use the word *Chicago* to mean the people of that city. As we carefully examine what the Bible actually tells us about Jerusalem, its relevance to our lives will become evident. To begin with, understanding something of its past and its present is critical to understanding its future and ultimately our future.

JERUSALEM

WHY JERUSALEM?

In the Old Testament, God declared, "I have chosen Jerusalem that My name might be there" (II Chronicles 6:6). In human terms we could say that He has boldly put His reputation on the line. Furthermore, God chose the location of the present earthly Jerusalem (or Zion) to be the future location of His permanent home.

> *For the LORD has chosen Zion; He has desired it for His habitation. "This is My resting place forever; Here I will dwell, for I have desired it." Psalm 132:13–14*

The Bible contains other prophecies that emphasize the permanence of this promise.

> *"Sing for joy and be glad, O daughter of Zion; for behold I am coming and I will dwell in your midst," declares the LORD. "Many nations will join themselves to the LORD in that day and will become My people. Then I will dwell in your midst, and you will know that the LORD of hosts has sent Me to you." The LORD will possess Judah as His portion in the holy land, and will again choose Jerusalem. Be silent, all flesh, before the LORD; for He is aroused from His holy habitation. Zechariah 2:10–13*

> *But Judah will be inhabited forever and Jerusalem for all generations. Joel 3:20*

This future Jerusalem will last forever and God Himself will dwell there. The prophet Jeremiah gives more specifics.

> *"'Because they have called you an outcast, saying: "It is Zion; no one cares for her."' Thus says the LORD, 'Behold, I will restore the fortunes of the tents of Jacob and have compassion on his dwelling places; and the city will be rebuilt on its ruin....'"* Jeremiah 30:17b–18

The Hebrew word for *rebuilt* can mean *set up*. The phrase "on its ruin" is the single Hebrew word *tel*, which is now used as an archeological term meaning *the site of a ruined city*. At the time Jeremiah was writing, Jerusalem had been destroyed. However, in the very next chapter, he explains some key details about a future Jerusalem. A new city called Jerusalem will be set upon the very site of the old city; however, it will be much larger. He names specific places to give the extent of its size.

> *"Behold, days are coming," declares the LORD, "when the city will be rebuilt for the LORD from the Tower of Hananel to the Corner Gate. The measuring line will go out farther straight ahead to the hill Gareb; then it will turn to Goah." Jeremiah 31:38–39*

The people who heard Jeremiah's prophecy realized this enlargement of Jerusalem meant the topography of their land

26

would be changed. If the measuring line will go straight out to a hill, evidently a valley will be filled in. This expansion is referred to by other prophets. Zechariah gives a dramatic prophecy that describes massive changes that will occur in the future not only to Jerusalem but to the entire area surrounding it.

> *All the land will be changed into a plain from Geba to Rimmon south of Jerusalem; but Jerusalem will rise and remain on its site from Benjamin's Gate as far as the place of the First Gate to the Corner Gate, and from the Tower of Hananel to the king's wine presses. People will live in it, and there will no longer be a curse, for Jerusalem will dwell in security.* Zechariah 14:10–11

This large portion of land from Geba to Rimmon will be raised up most likely as a plateau, forming a base for the new city of Jerusalem. This will be discussed further in the next chapter.[1]

EZEKIEL'S VISION

The prophet Ezekiel is transported into the future to actually see the result of these topographical changes that Jeremiah alludes to and Zechariah explains. Details of place names as well as measurements are clues to link these three prophecies together. Ezekiel says, "[God] brought me into the land of Israel and set me on a very high mountain" (Ezekiel 40:2). Ezekiel calls this plateau, this specially designated piece of real estate, the Holy Allotment (Ezekiel 45:1–7). While Ezekiel is standing on this elevated land, God tells him, "This is the place of My throne and the place of the soles of My feet, where I will dwell among the sons of Israel forever" (Ezekiel 43:7). The word *throne* means the seat of Christ's government, or His capital. Not only will it be a physical or political center but a spiritual center as well. All of this property will be considered not just holy (in Hebrew *kodesh*), or set apart, but *kodesh kodesh*, or most holy.[2]

> *This is the law of the house: its entire area on the top of the mountain all around shall be most holy."* Ezekiel 43:12a

A VERY SPECIAL CITY

An angelic messenger gives Ezekiel a grand tour of this Holy Allotment, a large square portion of land containing a temple in the center with suburbs around the temple for the priests. This future temple will be the central place of worship for the entire world because God says, "My house will be called a house of prayer for all the peoples" (Isaiah 56:7). The prophet Zechariah preached,

> *"Thus says the LORD of hosts, 'It will yet be that peoples will come, even the inhabitants of many cities.'"* Zechariah 8:20

> *"And it shall be from new moon to new moon and from sabbath to sabbath, all mankind will come to bow down before Me," says the LORD.* Isaiah 66:23

27

Also at the south end, separate from the temple, is a specially designated piece of property for a city. The portion of land for this city is square at its base. Ezekiel describes the city's gates, three on each of the four sides. Each gate is named for one of the tribes of Israel: on the north, Reuben, Judah, Levi; on the east, Joseph, Benjamin, Dan; on the south, Simeon, Issachar, Zebulun; on the west, Gad, Asher, Naphtali (Ezekiel 48:30–34). At the conclusion of his tour, Ezekiel hears a profound proclamation: "The name of the city from that day shall be 'The LORD is there'" (Ezekiel 48:35). The very name of this city is a bold claim that within this city the once broken fellowship of God with man will be gloriously restored. And it is not only restored but restored permanently, from that day on. God promised that He would again dwell in our midst, and here is that fulfillment, that dream come true, that happily ever after.

Thus we see a very special city with unique characteristics:

1. The city is located in the land of Israel.
2. The city is separate from the temple.
3. The city has a square base.
4. The city has twelve gates, three on each side.
5. Each gate is named for one of the twelve tribes of Israel.
6. The city is located on a portion of land that is designated Most Holy.
7. The city will be the capital of the world.
8. The Lord will be there in the city.
9. The Lord will be there in the city forever.

As we compare all the prophecies discussed previously with this prophecy of Ezekiel's, we know that this future city will not only be called *The Lord is there* but will also go by the name *Jerusalem*.

WHAT IS THE HEAVENLY JERUSALEM?

The Bible also says that a city presently exists in heaven called *Jerusalem*.

> *But you have come to Mount Zion and to the city of the living God, the heavenly Jerusalem, and to myriads of angels, to the general assembly and church of the firstborn who are enrolled in heaven, and to God, the Judge of all, and to the spirits of the righteous made perfect, and to Jesus, the mediator of a new covenant.* Hebrews 12:22–24a

It is possible that this city could be hovering over Israel right now but in an unknown dimension. Although it is not normally visible to us, God made exceptions to this when Jacob saw a ladder reaching up to the gate of heaven (Genesis 28:17). Also, Stephen looked up and saw Jesus in heaven (Acts 7:55–56). Psalm 68, if taken literally, gives this location quite plainly.

> *To Him who rides upon the highest heavens, which are from ancient times; … His majesty is over Israel and His strength is in the skies. O God, You are awesome from Your sanctuary.…* Psalm 68:33–35

JOHN'S VISION

In the book of Revelation, the last book of the Bible, the author, John, also had a vision of the future. He tells us that God "carried me away in the Spirit to a great and high mountain" (21:10). Then like Ezekiel, while John was standing on elevated land, God showed him a city. It was "the holy city, Jerusalem, coming down out of heaven from God" (21:10). "The righteous made perfect" live in this city (Hebrews 12:23). In other words, some people who died had the privilege to go to this heavenly city. When John saw it descending to earth, it was full of immortal inhabitants. John says there was no temple in it (Revelation 21:22). He also said it was square at the base, and its size was huge (21:16). It had twelve gates, three on each side, with each gate named after the twelve tribes of Israel (21:12–13). Nothing that defiles is allowed to enter the city; thus it is holy (21:27). John also says that the throne of God will be in that very city (22:3–5). It will be God's capital. It is also God's home, for the very presence of God will be there.

And I heard a loud voice from the throne, saying, "Behold, the tabernacle of God is among men, and He will dwell among them, and they shall be His people, and God Himself will be among them." Revelation 21:3

WHY IS THERE NO TEMPLE IN THE CITY?

John specifically says there is no need of a temple in this new Jerusalem.

I saw no temple in it, for the Lord God the Almighty and the Lamb are its temple. Revelation 21:22

This correlates with Ezekiel's vision of the Holy Allotment. The temple and the city are separate but in close proximity to one another. Since the entire Holy Allotment is the *throne*, or the seat of Christ's government, it would be similar to Washington D.C.'s containing both the White House and the National Cathedral. Ezekiel talks of this distinction of two separate places within the vicinity of each other, a place for a city and a separate place for a temple. Thus, the temple apart from the city will be the worship center for mortals. The righteous immortals live in God's dwelling place, the New Jerusalem. They have no need of a temple because they have the incredible privilege of direct access to God.

"I will make a covenant of peace with them; it will be an everlasting covenant with them. And I will place them and multiply them, and will set My sanctuary in their midst forever. My dwelling place also will be with them; and I will be their God, and they will be My people." Ezekiel 37:26–27

The overwhelming number of similarities between these two visions points to the idea that Ezekiel and John are talking about the same city.[3]

WILL THE CITY ACTUALLY LAND?

The book of Isaiah has many references concerning this future New Jerusalem. Isaiah talks about God's radiant glory appearing in connection with the city.

> "Arise, shine; for your light has come, and the glory of the LORD has risen upon you. For behold, darkness will cover the earth and deep darkness the peoples; but the LORD will rise upon you and His glory will appear upon you. Nations will come to your light, and kings to the brightness of your rising. Lift up your eyes round about and see; they all gather together, they come to you. Your sons will come from afar, and your daughters will be carried in the arms. … And they will call you the city of the LORD, the Zion of the Holy One of Israel." Isaiah 60:1–4, 14b

He talks about the change from the old city to the new city occurring on the same location. He says, "Shake thyself from the dust; arise, and sit down" (Isaiah 52:2 KJV). This implies a joining. The land rises up, and the New Jerusalem is set down.

> Awake, awake; put on thy strength, O Zion; put on thy beautiful garments, O Jerusalem, the holy city: for henceforth there shall no more come into thee the uncircumcised and the unclean. Shake thyself from the dust; arise, and sit down, O Jerusalem. Isaiah 52:1–2a (KJV)

Isaiah makes it very clear that the future location of God's capital city will be on the land of present-day Jerusalem.

> Then the moon will be abashed and the sun ashamed, for the LORD of hosts will reign on Mount Zion and in Jerusalem…. Isaiah 24:23

IN REVIEW

When it comes to real estate, the three most important factors are location, location, location. God reveals that the site of the present-day city of Jerusalem is His sovereign choice for His future capital. We have looked at just a few of the prophecies concerning the topographical changes that will occur, preparing the earth to receive the city "whose architect and builder is God" (Hebrews 11:10). We have also seen that God gave both Ezekiel and John visions of what this city will look like. Amazing details about the size of this city will be covered in the next chapter. Most importantly, descriptions of specific characteristics will help us to get to know what God is like. We will see how someday the New Jerusalem on earth will be a source of blessing, not only to God's people who live in it but also to all the peoples of the world. Out of His great love, He has chosen to live among us.

Then the LORD will be zealous for His land and will have pity on His people

JOEL 2:18

I will give them one heart and one way, that they may fear Me always, for their own good and for the good of their children after them... I will rejoice over them to do them good and will faithfully plant them in this land with all My heart and with all My soul.

JEREMIAH 32:29 & 41

For the **LORD** of hosts will reign on Mount Zion and in Jerusalem....
Isaiah 24:23

chapter three
MAJESTIC MEASUREMENTS

WORD PICTURES OF GOD'S FUTURE Kingdom capital abound throughout the Bible like scattered puzzle pieces on a table. Thus far we have organized many pieces that give us clues concerning the location of this city. We have seen that someday a new and different city called Jerusalem will be located in the area of present-day Jerusalem. Also we have begun to examine the numerous similarities between John's vision of a New Jerusalem and Ezekiel's vision of a city on the Holy Allotment. Many have seen these connections, but a major difficulty in harmonizing them has been the subject of size. Nevertheless, both John and Ezekiel, along with other prophets, give us critical measurements. When these puzzle pieces are carefully compared, an amazing harmony comes to light. The issue of size dramatically becomes the key piece to assembling the puzzle.

THE KEY PIECE OF THE PUZZLE

As John begins to describe the vision God gave him of the New Jerusalem, he designates the size of the city that he saw.

And he carried me away in the Spirit to a great and high mountain, and showed me the holy city, Jerusalem, coming down out of heaven from God. ...The city is laid out as a square, and its length is as great as the width; and he measured the city with the rod, fifteen hundred miles; its length and width and height are equal. Revelation 21:10, 16

The Greek word translated miles is stadia and the precise size of a stadia is not known thus we can only estimate this measurement. The measurement has been calculated to be approximately 1380 miles and most Bible translations round that number to 1,500 miles. Many have assumed that this is the linear distance measured in each direction: length, width, and height. Thus the base alone would be equal to approximately two thirds the size of the United States. At first this seems so huge that it is difficult to grasp. Of course, the Creator of the universe could easily make the city any size He wants. However, if we keep in mind the references we have already discussed, a city or structure of this size and particularly this height connecting with the earth presents major problems. For instance, unless God drastically changed many physical laws, this massive structure landing on the earth would throw off the earth's rotation.

If we examine all of the Scriptures that could possibly shed light on this issue of size, we find some surprising correlations. Looking back at the wording of Revelation 21:16, we see that John says the city was "laid out as a square, and its length is as great as the width." In other words, John is simply letting us know that the city has a square-shaped base. He then says that his angel escort measured the city with a measuring rod. Since there are three gates on each side of the city that John saw, and if they are evenly spaced, the angel would only have to measure from one corner to the first gate to give John the approximate overall size. The number given in verse 16 is immediately followed by the phrase "its length and width and height are equal." The specific mention of the three dimensions might possibly mean that the 12,000 *stadia* (or 1,380 miles) refer to a cubed measurement. That means the city that John saw was approximately 11 miles in length, 11 miles in width, and 11 miles in height. Thus, its outward dimensions would total 1,331 cubic miles, reasonably close to the estimate of 1,380 miles. Again, we should keep in mind that scholars are not sure of the exact size of a *stadia* and also that the Greek word for *equal* means *an estimated size*.

As we examine this possible interpretation, we will crosscheck it using both biblical and extra-biblical sources. The question that matters is this: What did the people of John's day understand this phrase to mean? What was the culture of the ancient Middle East and particularly first century Israel? Although there are no other examples of cubed measurements in the Bible, there is a good deal of evidence outside of the Bible of such measurements being used well before John's lifetime. The Babylonians had already developed a formula for approximating square roots by 2,000 B.C. Israel had been conquered by the Babylonians in 586 B.C. Then 300 years prior to John, Alexander the Great became the ruling power. Although the Romans conquered the Greeks just before John's lifetime, Alexander had advanced the Greek way of life, deeply affecting Israelite culture. Interestingly, it has been said that geometry "was something of an obsession for the Ancient Greeks."[2] Hero of Alexandria lived during John's lifetime and wrote of methods for finding approximate numerical square and cube roots.[3]

However, what the Bible itself reveals is most critical, and those who would listen to John would have been familiar with the Old Testament writings. The prophecies of Isaiah, Zechariah, and Jeremiah that we have already looked at would have been well known. But the most detailed revelation was given to Ezekiel. Similar to that in John's vision, Ezekiel's angel escort had a

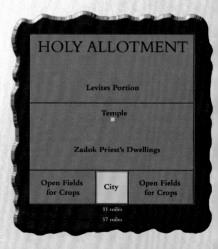

HOLY ALLOTMENT

Levites Portion

Temple

Zadok Priest's Dwellings

| Open Fields for Crops | City | Open Fields for Crops |

11 miles

57 miles

measuring rod. The angelic surveyor gives extremely thorough measurements of the Holy Allotment, the temple that would be in its center, and the city that would be at one end (Ezekiel 40–48). Again, when converting the Hebrew units of measure *cubits* and *rods*, we can only estimate. According to one calculation, the entire Holy Allotment is 57 miles square (Ezekiel 45:1–7). On the south end of this square portion, the place for the city is 11 miles square (Ezekiel 45:6; 48:15–20, 30–35).[4] This is an amazing correlation.

We already discussed how Jeremiah predicted that this future Jerusalem would be greatly expanded (Jeremiah 31:38–39). The people of John's day who were familiar with Ezekiel's prophecy would have understood that this immense size could not possibly fit on the land contour of Israel. Also, they knew about the great topographical changes predicted by Zechariah.

> *All the land will be changed into a plain from Geba to Rimmon south of Jerusalem; but Jerusalem will rise and remain on its site....*
> Zechariah 14:10

Helping us to link the puzzle together, God gives measurable sizes. Geba was 10 miles north of Jerusalem, and Rimmon was 35 miles southwest of Jerusalem. This means a raised plateau at least as big as 45 miles in length would be formed.[5] Thus, recognizing that all our dimensions are approximate, Ezekiel's

Holy Allotment would fit on the elevated land described by Zechariah. The plateau would also form a base for God's capital city, the New Jerusalem.

Finally, amazing evidence outside the Bible indicates that at least some of those first readers of John's vision of the New Jerusalem understood the connection to Ezekiel's Holy Allotment city. Interestingly, the writings of the Dead Sea Scrolls contain several fragmentary copies of a document discussing this. In *A Vision of the New Jerusalem* dimensions of the city are given. The authors of *The Dead Sea Scrolls, a New Translation*[6] calculate a *stade* to be 2/15 of a mile. They say this ancient document would be saying that the New Jerusalem would be 18.67 miles by 13.33 miles (4th Qumran cave #554, Fragment 2, Column 1). The measurements between each of the gates are given by each name of Israel's twelve tribes. Fragment 3, Column 2 even names some of the jewels used in its construction and says, "its beams were gold."[7]

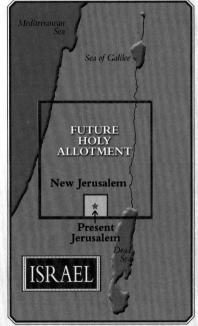

HOW WILL ALL THIS HAPPEN?

These prophecies of Jeremiah, Zechariah, and Ezekiel are actually describing the future topography of the land of Israel. The event that initiates those changes is sometimes called Messiah's Earthquake.[8] One day God will bring judgment upon the world. This will be climaxed by the seventh bowl judgment, the most powerful earthquake ever in the history of our planet. All over the earth today, we see evidence that at some time in the past there has been catastrophic movement of the earth's crust. That evidence can be shown to be a consequence of the worldwide Flood. God tells us that this final Judgment will be even worse than that.

> Then the seventh angel poured out his bowl upon the air,
> and a loud voice came out of the temple from the throne,
> saying, "It is done." And there were flashes of lightning and
> sounds and peals of thunder; and there was a great earth-
> quake, such as there had not been since man came to be
> upon the earth, so great an earthquake was it, and so mighty.
> Revelation 16:17–18

The Bible is full of references about transformations that will occur in the end times—changes so profound that they will affect even the earth's crust. Each of the following passages describes this event because they link topographical changes with God's coming to earth.

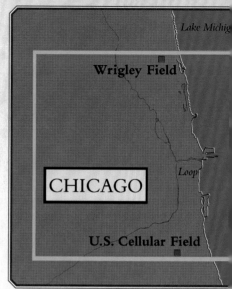

> "The fish of the sea, the
> birds of the heavens, the
> beasts of the field, all
> the creeping things that
> creep on the earth, and
> all the men who are on
> the face of the earth will
> shake at My presence;
> the mountains also will
> be thrown down, the
> steep pathways will
> collapse and every wall
> will fall to the ground."
> Ezekiel 38:20

> I looked on the mountains,
> and behold, they were quaking, and all the hills moved to and
> fro. I looked, and behold, there was no man, and all the birds
> of the heavens had fled. I looked, and behold, the fruitful land
> was a wilderness, and all its cities were pulled down before the
> LORD, before His fierce anger. Jeremiah 4:24–26

> Mountains quake because of Him and the hills dissolve;
> indeed the earth is upheaved by His presence, the world
> and all the inhabitants in it. Who can stand before His
> indignation? Who can endure the burning of His anger?

His wrath is poured out like fire and the rocks are broken up by Him. Nahum 1:5–6

Behold, the LORD lays the earth waste, devastates it, distorts its surface and scatters its inhabitants. ... For the windows above are opened, and the foundations of the earth shake. The earth is broken asunder, the earth is split through, the earth is shaken violently. The earth reels to and fro like a drunkard and it totters like a shack, for its transgression is heavy upon it, and it will fall, never to rise again. Isaiah 24:1, 18b–20

For behold, the LORD is coming forth from His place. He will come down and tread on the high places of the earth. The mountains will melt under Him and the valleys will be split, like wax before the fire, like water poured down a steep place. Micah 1:3–4

"Let every valley be lifted up, and every mountain and hill be made low; and let the rough ground become a plain, and the rugged terrain a broad valley; then the glory of the LORD will be revealed, and all flesh will see it together; for the mouth of the LORD has spoken." ... Get yourself up on a high mountain, O Zion, bearer of good news, lift up your voice mightily, O Jerusalem, bearer of good news; lift it up, do not fear. Say to the cities of Judah, "Here is your God!" Isaiah 40:4–5, 9

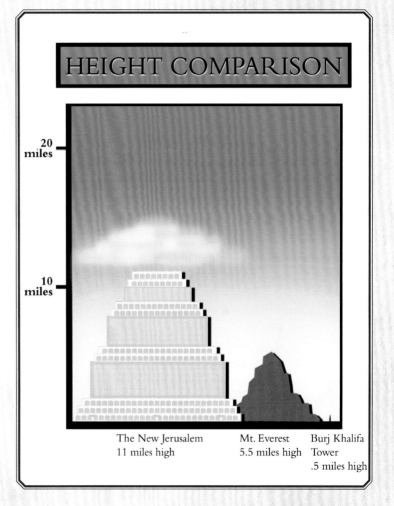

HEIGHT COMPARISON

20 miles

10 miles

The New Jerusalem
11 miles high

Mt. Everest
5.5 miles high

Burj Khalifa
Tower
.5 miles high

A NEW DEFINITION OF HUGE

In the end this terrifying upheaval of our planet will prepare it for the arrival of the biggest single edifice ever seen. The massive New Jerusalem will stretch out upon the Holy Allotment plateau 11 miles in length and 11 miles in width. Now, trying to picture a single enclosed structure of this size is not easy. This is approximately the distance in Chicago between Wrigley Field and U.S. Cellular Field. And imagine a building stretching 11 miles into the sky! If we looked out the window of a commercial jet flying at an altitude of 30,000 feet, we would only be about halfway up to the top. Or what if we stood at the gate and gazed up? This new Jerusalem would be about double the height of the Himalayas. Can our eyes even grasp the reality? However, in order for the whole picture to really take shape, we will explore that very subject in the next chapter. As we examine other prophecies God has revealed about the shape of His future capital, the puzzle pieces should fit without being forced.

In conclusion, the harmony of Old and New Testament evidence is exciting. In addition, the extra-biblical evidence found in the Dead Sea Scroll documents shows that at least some first century readers of John's Gospel saw this harmony. John finishes the picture that Ezekiel started. But even more critical, God will finish what He started. Because of His faithful love, His heavenly house will land.

> That you...may be able to comprehend with all the saints what is the breath and length and height and depth, and to know the love of Christ which surpasses knowledge, that you may be filled up to all the fullness of God.
>
> EPHESIANS 3:18, 19

chapter four
☐ GOD'S HOLY MOUNTAIN ☐

THE BIBLE CONTAINS MANY CLUES hinting at the shape of God's city. Since John gives us three dimensions, the length, the width, and the height, many have speculated that the city is a cube. Some have thought it could even be a sphere. The Bible's most direct and detailed description of the New Jerusalem gives only a hint of the overall shape of the city structure.

> And he carried me away in the Spirit to a great, high mountain, and showed me the holy city Jerusalem coming down out of heaven from God. ... And the wall of the city had twelve foundations, and on them were the twelve names of the twelve apostles of the Lamb. Revelation 21:10, 14 (ESV)

Since John saw the twelve foundations inscribed with the names of the twelve apostles and each foundation or layer was visible, this could indicate that the entire city looks like a step pyramid.[1] As we examine evidence from both the Old and the New Testament, and from archeology as well, a strong case can be made for a triangular shape.

A STEP PYRAMID SHAPE

Ezekiel's first mention of the city reveals an intriguing clue concerning its overall appearance.

> In the visions of God He brought me into the land of Israel and set me on a very high mountain, and on it to the south there was a structure like a city. Ezekiel 40:2

A *structure* that looks like a city seems to indicate a unified whole of some sort. In addition, the prophet Amos gives us another hint. *It is he* [God] *that buildeth his stories in the heaven* (Amos 9:6 KJV). The word *stories* is most often translated as *stairs* or *steps*. It is the same word that is translated as *degrees* in the titles for Psalms 120–134 (*A Song of Degrees*).[2] It is interesting to note that these psalms were treated as a group by the Israelites. In the Hebrew, Psalm 128, 129, and 130 were counted as only one psalm. Psalm 125 and 126 were also counted as one. Thus, they had 12 psalms to sing, one for each of 12 steps, or levels. They sang these songs as they ascended to the Temple Mount in Jerusalem. Within this *Song of Steps* is a fascinating verse. Note the word *compact*, which can mean *to couple, heap up, join*.[3]

> Our feet are standing within your gates, O Jerusalem, Jerusalem, that is built as a city that is compact together. Psalm 122:2–3

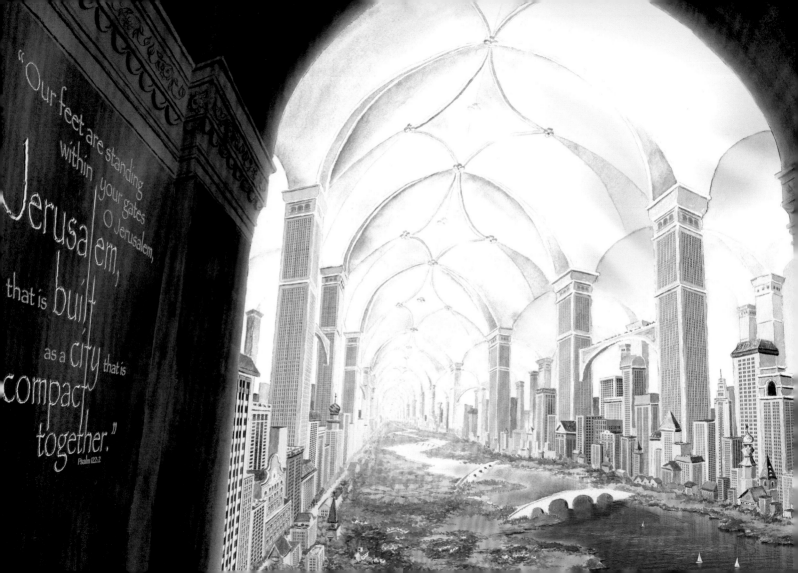

"Our feet are standing
within your gates,
O Jerusalem,
Jerusalem,
that is built,
as a city that is
compact
together."

Psalm 122:2

If the New Jerusalem is in the shape of a step pyramid, it could actually be a configuration of cities built one upon another.

All of these are mere hints at what God's city looks like. The clearest evidence is the fact that numerous Old Testament references depict God's dwelling place as a mountain. At the time of their writing, some of these references also had both a present and a future application. In other words, they could have been referring to the then present earthly Jerusalem, upon the natural height of Mt. Zion. However, in a broader sense, these verses could also be referring to the heavenly Jerusalem that in the future will descend to earth.

I was crying to the LORD with my voice, and He answered me from His holy mountain. Psalm 3:4

O LORD, who may abide in Your tent? Who may dwell on Your holy hill? Psalm 15:1

His foundation is in the holy mountains. The LORD loves the gates of Zion more than all the other dwelling places of Jacob. Glorious things are spoken of you, O city of God. Psalm 87:1–3

"But as for Me, I have installed My King upon Zion, My holy mountain." Psalm 2:6

Great is the LORD, and greatly to be praised, in the city of our God, His holy mountain. Beautiful in elevation, the joy of the whole earth, is Mount Zion in the far north, the city of the great King. Psalm 48:1–2

"… He who takes refuge in Me will inherit the land and will possess My holy mountain." Isaiah 57:13

"I will bring forth offspring from Jacob, and an heir of My mountains from Judah; even My chosen ones shall inherit it, and My servants will dwell there. Sharon will be a pasture land for flocks, and the valley of Achor a resting place for herds, for My people who seek Me. But you who forsake the LORD, who forget My holy mountain, who set a table for Fortune, and who fill cups with mixed wine for Destiny, I will destine you for the sword." Isaiah 65:9–12a

The following psalm predicts that Bashan, a mountain range in Israel noted for its height, will be envious of the future height of God's holy mountain.

A mountain of God is the mountain of Bashan; a mountain of many peaks is the mountain of Bashan. Why do you look with envy, O mountains with many peaks, at the mountain which God has desired for His abode? Surely the Lord will dwell there forever. Psalm 68:15–16

THE MT. SINAI CONNECTION

The case for a pyramid-shaped New Jerusalem gets even stronger when we look at a key prophecy given in the book of Exodus. While the Israelites were rejoicing immediately after the Red Sea crossing, Moses foretold that God would bring them to a specially designated mountain.

> *"You will bring them and plant them in the mountain of Your inheritance, the place, O LORD, which You have made for Your dwelling, the sanctuary, O Lord, which Your hands have established. The LORD shall reign forever and ever."* Exodus 15:17–18

Their first taste of this was the encampment around Mount Sinai where Moses received the Ten Commandments. God's presence was manifested at first by the cloud and fire at the top of Mt. Sinai (Exodus 24:16–17). Only a chosen few were allowed to go up into His presence. Most were not even allowed to touch the mountain, for God had said, "Set bounds about the mountain and consecrate it" (Exodus 19:23). It is important to note the overall layout of Mt. Sinai. The tent dwellings of the Israelites were at its base, and eventually the worship center or Tabernacle was in the midst of those dwellings. The tents of the Levites, the priestly tribe, had the privilege of being the closest, encircling the Tabernacle. This configuration was a foreshadowing of the distant future. In other words, one unique mountain was a picture of another unique mountain.

Later on when the Israelites arrived in the Promised Land, their dwellings and their worship center, the temple, was located upon the natural heights of Jerusalem. However, the picture of Sinai pointed toward something that is still in the future. Someday God will dwell "*in* the mountain of [His] inheritance" where He will "reign forever and ever" (Exodus 15:17–18). The idea is that the New Jerusalem is that mountain. God will live in that mountain and rule and reign from

His voice shook the earth then, but now He has promised, saying, Yet once more I will shake not only the earth,

that location. Now if we look back at Ezekiel's entire layout of the Holy Allotment with that assumption, the full configuration echoes the layout at Mt. Sinai.

Details about the New Jerusalem confirm this comparison. When God's city lands on the earth, it will be inhabited by immortals. It will be off limits to mortals. John tells us, "nothing unclean, and no one who practices abomination and lying, shall ever come into it, but only those whose names are written in the Lamb's book of life" (Revelation 21:27). John even tells us that though the twelve gates are always open, an angel guards each gate (Revelation 21:12, 25). A temple will be separate and out in front, where mortals can worship. Just like the priestly tribe of Levi set up their tents around the Tabernacle, the descendants of the Levitical priestly family of Zadok will live around the immediate perimeter of Ezekiel's Temple. The rest of the descendants of the tribe of Levi will live in the adjacent portion.

The New Testament confirms this connection, making direct comparisons between Mt. Sinai and the New Jerusalem both in Galatians (4:25) and in Hebrews (12:18–29). This later section discusses the similarities and differences in great detail, implying that both were mountains. The author reminds us that the earth quaked at Mt. Sinai then predicts that someday not just earth but also heaven will be shaken.

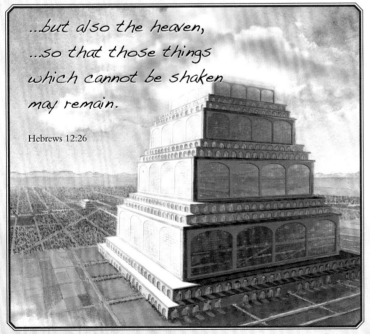

...but also the heaven,
...so that those things
which cannot be shaken
may remain.

Hebrews 12:26

> And [God's] voice shook the earth then, but now He has promised, saying, "Yet once more I will shake not only the earth, but also the heaven." This expression, "Yet once more," denotes the removing of those things which can be shaken, as of created things, so that those things which cannot be shaken may remain. Hebrews 12:26–27

The Old Testament quote within this New Testament verse comes from Haggai 2:6. It refers to the topographical recon-

figuration that God will bring just prior to the setting up of His Kingdom. After catastrophic upheaval of both the earth and the heavens, "things which cannot be shaken" will remain. The mountain of Sinai, which represented what is temporary, will be replaced by something permanent, God's Holy Mountain, the New Jerusalem. (The timing of all this will be discussed in the next chapter.)

THE CANOPY

One more fascinating prophecy shows a striking similarity between Mt. Sinai and the New Jerusalem. Isaiah tells us about an immense cloud canopy "over the whole area of Mt. Zion" which will offer a special protection over God's mountain-shaped city.

> *Then the LORD will create over the whole area of Mount Zion and over her assemblies a cloud by day, even smoke, and the brightness of a flaming fire by night; for over all the glory will be a canopy. There will be a shelter to give shade from the heat by day, and refuge and protection from the storm and the rain.* Isaiah 4:5–6

This future canopy was prefigured by the cloud and fire that was over Mt. Sinai, indicating God's presence.

> *Now Mount Sinai was all in smoke because the LORD descended upon it in fire; and its smoke ascended like the smoke of a furnace, and the whole mountain quaked violently.* Exodus 19:18

However, Isaiah's cloud is much larger and different than a normal cloud, for it provides protection from weather. It would be like a giant biome, creating a unique ecosystem for God's capital city.

TRADITION!

In conclusion, it is somewhat intriguing that traditions that developed over time sometimes point to biblical truths more than we realize. Take wedding customs, for example. Is it only coincidence that the shape of the New Jerusalem could be similar to the triangular shape of a multi-tiered wedding cake with the bride and groom together on top with even a canopy (a *chuppah*) over them?

NO NIGHT THERE

Besides having its own unique climate, the New Jerusalem also has its own light source. This is not saying that the sun does not exist but that the city has no need of it.

> *And the city had no need of the sun, neither of the moon, to shine in it: for the glory of God did lighten it, and the Lamb is the light thereof.* Revelation 21:23 (KJV)

Isaiah had foretold this hundreds of years before John. Speaking to earthly Jerusalem, he predicts that a future Jerusalem will

have the Lord for its light source. The pronouns localize the meaning of the statement.

> *"No longer will you have the sun for light by day, nor for brightness will the moon give you light; but you will have the LORD for an everlasting light, and your God for your glory. Your sun will no longer set, nor will your moon wane; for you will have the LORD for an everlasting light, and the days of your mourning will be over." Isaiah 60:19–20*

These prophecies agree then with those that say the sun, moon, and stars will continue to exist.

> *Praise Him, sun and moon; praise Him, all stars of light! … For He commanded and they were created. He has also established them forever and ever; He has made a decree which will not pass away. Psalm 148:3, 5b–6*

> *"Once I have sworn by My holiness; I will not lie to David. His descendants shall endure forever and his throne as the sun before Me. It shall be established forever like the moon, and the witness in the sky is faithful." Psalm 89:35–37*

Appropriately for the immortal inhabitants, the New Jerusalem is a city that never sleeps!

> *And there shall be no night there. Revelation 22:5a (KJV)*

So far, we have seen evidence from both the Old and the New Testament indicating that the New Jerusalem is likely a pyramid-shaped, self-contained structure that presently exists up in heaven but will someday come to earth. Thus a question arises. Since this will be the paradise that will be regained, could this be the actual paradise that was lost?

WHERE WAS EDEN?

Scholars have long speculated that in the beginning, God's Holy Mountain was actually on earth. Ezekiel hints at this, giving us a glimpse into the past. The following passages reveal that Satan once had a privileged position "on the holy mountain of God." He was cast down from that mountain because sin was found in him. These verses also tell us that the location of Eden was on that holy mountain. In addition, the fact that four rivers had their source in Eden implies that it was elevated (Genesis 2:10–14).[4]

> *"You were in Eden, the garden of God. … You were the anointed cherub who covers, and I placed you there. You were on the holy mountain of God; you walked in the midst of the stones of fire. You were blameless in your ways from the day you were created until unrighteousness was found in you. … And you sinned; therefore I have cast you as profane from the mountain of God. … I cast you to the ground…." Ezekiel 28:13–17*

"There will be no night there."

Revelation 22:25

In fact, it is possible that the first chapter of Genesis reinforces this view:

> *And God called the firmament Heaven.* Genesis 1:8a (KJV)

Some who have done research into the meaning of the word *firmament* say that it actually means *a pressed out solid,* referring to the earth's crust. In other words, the verse should read, "God called the earth Heaven."[5] Thus, according to this interpretation, Eden was in God's Holy Mountain, and heaven was on earth.[6] After the Fall, we are told not that God moved Eden to another place but that He put a cherub at the entrance of Eden to prevent Adam and Eve from returning and eating from the Tree of Life. If God did not remove His Holy Mountain up into another realm right away, then ancient peoples of the world would have some knowledge of what at least the exterior of God's home looked like. Interestingly, the first thing people did when they began to repopulate the earth after the Flood was build a city with a tower.

> They said, "Come, let us build for ourselves a city, and
> a tower whose top will reach into heaven...."
> Genesis 11:4

The Hebrew word for *tower* used in this verse includes the meaning of a pyramid-shaped structure. Therefore, Babel would be an imitation of God's Holy Mountain.

EXTRA-BIBLICAL EVIDENCE

We cannot be sure whether or not the structure of God's city was visible to the antediluvian world. However, we do see an amazing amount of evidence that, at the least, ancient cultures connected belief in an afterlife with a mountain-like shape. All over the earth, ancient civilizations built step pyramids for their religious worship. Besides the more famous pyramids in Egypt, these structures are found in Greece, Mesopotamia, India, China, Mexico, and areas North America.

Since many ancient people groups have Bible-like creation and flood stories and sacrificial rites prior to the writing of the Old Testament, it is highly possible that these post-Flood people groups had some knowledge of God's Holy City that was passed on by word of mouth from Adam through Noah and his descendants.[7] Maybe they were following Babel's example.

GIZA PYRAMIDS, EGYPT

The most pronounced feature of Mesopotamian temple architecture was the ziggurat. The lavish expenditure of labor required for the erection of these artificial mountains and their centrality to the cult has caused a general scholarly agree-

ment that the structures represent the mythological cosmic mountain.[8]

A recent discovery in Egypt by archeologists found ancient graves of some 600 workers, and some of the graves had mini pyramids on them that were several feet high. They felt this discovery could indicate that the idea of pyramid-type structures in relation to the afterlife was a belief held first by the common people and later used by kings.[9] Similar to the world-wide flood stories, without inspired writings from God, oral accounts of what God's home had looked like and who could go there became twisted and corrupted.

> *The Step Pyramid itself developed from the mudbrick royal mastabas of the Early Dynastic Period (c. 3100–c.2686 BC) at Abydos. ...The mudbrick mastaba developed into a stone-built tower, and the mound became a ladder, which the king climbed to join the "imperishable stars," a claim made in the Pyramid Texts, the funerary texts that accompanied royal burials during the Old Kingdom and First Intermediate Period (c.2686–2055 BC).*[10]

TENAYUCA, MEXICO

The Pyramid Texts are a collection of spells that were meant to ensure the resurrection of the king and his union with the gods in the sky.[11]

Speaking of Djoser's pyramid in Egypt,

> *Its bold shape—six great tiers of decreasing size—announced a divine truth that the humblest passerby in Djoser's time understood. The Step Pyramid was a ladder. Not the symbol of a ladder but an actual one, by which the soul of the dead ruler might climb to the sky, joining the gods in immortality.*[12]

This graffiti was written by visitors expressing admiration for the Djoser monument approximately 1500 years after it was built:

> *"The scribe Ahmose, son of Iptah, came to see the temple of Djoser. He found it as though heaven were within it, Re rising in it.*[13]

GANGAIKONDA CHOLAPURAM, INDIA

PYRAMID OF DJOSER, EGYPT

In fact, "The word *pharaoh* means *great house* and originally referred to the palace rather than the king." Also, "The Arabs used to call the Great Pyramid 'the mountain of Pharaoh.'" Putting these two definitions together, the pyramid structure could have been called "the mountain of the great house."[14] In studying about the ancient pyramids, we find other interesting parallels. Many times a temple was in front of the pyramid, connected by a special roadway. The temple was there for mortals to worship, while the pyramid was a house for an immortal soul. Other structures surrounded the temple and were used as dwelling places for the priests. In fact, reconstructed models of the city of Babylon show this same configuration.

All of this echoes Ezekiel's layout in the Holy Allotment. We know that Ezekiel was carried away as a captive to Babylon when Israel was conquered in 586 B.C. Some might think that when he saw Babylon he then wrote his prophecy, copying what he saw. To the contrary, what he saw was an imitation or copy of God's original.

PLATEAU OR PEAKED?

It is important to understand that the word *moun-*

SANTA CECILIA ACATITLAN, MEXICO

tain in both Hebrew and Greek can mean not only what we would traditionally call a single mountain with a peak but also a plateau, a rounded hill, or even a range of hills. We have assumed the Holy Allotment is on a plateau because of references previously given. However, the New Jerusalem itself is probably more of a triangular shape because the length, width, and height are equal. With this basic shape there is a wide variety of possibilities in design and style. Will it look like a Star Wars–type space station? Or maybe part of it will be more natural, like a Hobbit-type mountain home.

If the location of God's throne is at the top level as the centerpiece of the Golden City, then this would fit the symbolism of an often quoted passage:

… The stone [referring to Christ] which the builders rejected, the same is become the head of the corner.… Matthew 21:42 (KJV)

This verse in Matthew is quoted from Psalm 118:22. Since both the Hebrew and the Greek words for *head* mean *the highest part*, the symbol here reinforces the pyramid shape.

Isaiah gives a prophecy that concurs with this whole picture. The dwelling place of the Lord,

which actually looks like a mountain itself, is brought down to an elevated portion of land (the plateau), making the New Jerusalem's peak the highest point on earth. The Hebrew meaning of the word *established* means that this configuration will be permanent.

> Now it will come about that in the last days the mountain of the house of the LORD will be established as the chief of the mountains, and will be raised above the hills; and all the nations will stream to it. Isaiah 2:2

The following references also speak of God's "holy mountain," but they evidently have a broader meaning referring to the elevation upon which the New Jerusalem sits, the Holy Allotment plateau. This is where mortals will come and worship at the temple, separate from the City.

> "For on My holy mountain, on the high mountain of Israel," declares the Lord GOD, "there the whole house of Israel, all of them, will serve Me in the land; there I will accept them and there I will seek your contributions and the choicest of your gifts, with all your holy things." Ezekiel 20:40

> "Also the foreigners who join themselves to the LORD, to minister to Him, and to love the name of the LORD, ... even those I will bring to My holy mountain and make them joyful in My house of prayer. Their burnt offerings and their sacrifices will be acceptable on My altar; for My house will be called a house of prayer for all the peoples." Isaiah 56:6–7

> "Then they shall bring all your brethren from all the nations as a grain offering to the LORD, on horses, in chariots, in litters, on mules and on camels, to My holy mountain Jerusalem," says the LORD.... Isaiah 66:20

A HOME OR A HOTEL?

The city, although still huge, is not overwhelmingly supernatural. Based on the pyramid shape, we can calculate that

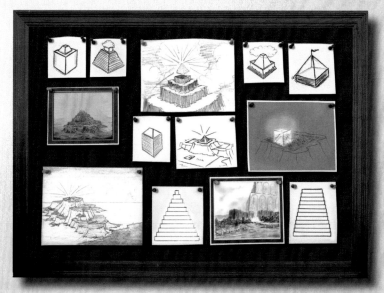

about two billion people would each have about 37,000 cubic feet of space. Of course, there will be differences in what kind of space immortal people will need. For instance, since there is no night there, it is very possible that bedrooms won't be needed. Also, if we compare the use of space in a skyscraper, a cruise ship, a mansion, or a space station and account for some extra large rooms and open spaces as well, the number of people would be lower.

Some have assumed that they will each receive a private mansion all to themselves (John 14:2–3). But we were told a place was being prepared for us in God's house. In other words, we don't necessarily receive a whole house to ourselves. Also, Jesus said He was going to prepare a place. Some have also assumed that this means their new home was under construction when this promise was given. However, the earthly equivalent of these heavenly preparations might be that just prior to our scheduled arrival, orders will be given to arrange fresh flowers in the vase, turn down the bed, lay out the chocolates, and leave the light on.

It is important to note that many immortals will be out and about, ruling and reigning with Christ as governors, mayors, and judges, maybe on a rotating basis. In other words, God's home will be more like a mansion or a hotel.

If we endure, we will also reign with Him. II Timothy 2:12a

"You have made them to be a kingdom and priests to our God; and they will reign upon the earth." Revelation 5:10

Blessed and holy is the one who has a part in the first resurrection; over these the second death has no power, but they will be priests of God and of Christ and will reign with Him for a thousand years. Revelation 20:6

And there will no longer be any night; and they will not have need of the light of a lamp nor the light of the sun, because the Lord God will illumine them; and they will reign forever and ever. Revelation 22:5

Behold, a king will reign righteously and princes will rule justly. Each will be like a refuge from the wind and a shelter from the storm, like streams of water in a dry country, like the shade of a huge rock in a parched land. Isaiah 32:1–2

... "Well done, good slave, because you have been faithful in a very little thing, you are to be in authority over ten cities. Luke 19:17

Or do you not know that the saints will judge the world? I Corinthians 6:2a

Let the godly ones exult in glory; let them sing for joy on their beds. Let the high praises of God be in their mouth, and a two-edged sword in their hand, to execute vengeance on the nations and punishment on the peoples, to bind their kings with chains and their nobles with fetters of iron, to execute on them the judgment written; this is an honor for all His godly ones. Praise the LORD! Psalm 149:5–9

So far, we have examined the big picture concerning the New Jerusalem, where it will land, how big it will be, and what shape it will have. Though the puzzle has taken shape, a most exciting question remains: When will the New Jerusalem appear and actually descend to earth?

I will return to Zion and will dwell in the midst of Jerusalem. Then Jerusalem will be called the City of Truth, and the mountain of the LORD of Hosts will be called the Holy Mountain.

ZECHARIAH 8:3

chapter five
THE ORDER OF EVENTS

HISTORY'S ULTIMATE CLIMAX WILL BE the most spectacular supernatural phenomenon ever seen. The Bible describes in vivid detail how people around the globe will see signs in the heavens above and on the earth beneath their feet. The main focus of this climax is the return of the Redeemer who will right all wrongs and bring a permanent peace to our planet. However, the epic will come full circle as He restores the paradise which has been lost. Jesus' own words connect His return directly to His Father's house, the New Jerusalem.

> *"In My Father's house are many dwelling places; if it were not so, I would have told you; for I go to prepare a place for you. If I go and prepare a place for you, I will come again and receive you to Myself, that where I am, there you may be also." John 14:2–3*

We must look carefully at the words that refer to a place. By saying "where I am, there you may be also," Jesus was referring back to the "many dwelling places" in His Father's house. In other words, Jesus was saying that when He comes,

He's bringing His house with Him. At the end of the Bible Jesus says,

> *"Behold, I am coming quickly, and My reward is with Me, to render to every man according to what he has done. I am the Alpha and the Omega, the first and the last, the beginning and the end." Blessed are those who wash their robes, so that they may have the right to the tree of life, and may enter by the gates into the city. Revelation 22:12–14*

Jesus refers to His coming and to the city in the same context. Those who have been washed from their sins will have the privilege of entering the gates of the city and will have the right to the tree of life.

As we now examine step by step what the Old Testament says concerning the timing of the future Jerusalem, we will find harmony. Again, the puzzle pieces fit. Many different prophets talk about the city's appearance, how that affects people on earth, and its actual descent. Some of these prophecies are clearer than others. Nevertheless, most of them give clues that help us link together a chronological order of events. To begin with, Isaiah gives a sweeping overview. While he links the glory of the Lord with the new future city of Jerusalem, he also reveals a critical clue. First there is deep darkness.

"Arise, shine; for your light has come, and the glory of the LORD has risen upon you. For behold, darkness will cover the earth and deep darkness the peoples; but the LORD will rise upon you and His glory will appear upon you. Nations will come to your light, and kings to the brightness of your rising. … And they will call you the city of the Lord, the Zion of the Holy One of Israel."
Isaiah 60:1–3, 14b

This contrast of a deep darkness dramatically pierced by brilliant light, along with reference to the future city of Jerusalem, is described by other prophets as well. Joel goes to great lengths to describe this event with gripping emotional and physical detail (Joel 2:1–32; 3:1–15). After mentioning the darkness, he says, "on Mount Zion and in Jerusalem there will be those who escape" (Joel 2:32). And again in the context of darkness he says,

The sun and moon grow dark and the stars lose their brightness. The LORD roars from Zion and utters His voice from Jerusalem, and the heavens and the earth tremble. But the LORD is a refuge for His people.… Then you will know that I am the LORD your God, dwelling in Zion, My holy mountain. So Jerusalem will be holy, and strangers will pass through it no more. Joel 3:15–17

However, a clearer description of this event comes from John.

… The sun became black as sackcloth made of hair, and the whole moon became like blood; and the stars of the sky fell to the earth, as a fig tree casts its unripe figs when shaken by a great wind. The sky was split apart like a scroll when it is rolled up, and every mountain and island were moved out of their places. Then the kings of the earth and the great men and the commanders and the rich and the strong and every slave and free man hid themselves in the caves and among the rocks of the mountains; and they said to the mountains and to the rocks, "Fall on us and hide us from the presence of Him who sits on the throne, and from the wrath of the Lamb; for the great day of their wrath has come, and who is able to stand?" Revelation 6:12–17

Somehow people on earth see something that definitely lets them know that the throne of God is near. In addition, Matthew, Mark, and Luke also talk of this. Matthew says,

"… The sun will be darkened, and the moon will not give its light, and the stars will fall from the sky, and the powers of the heavens will be shaken. And then the sign of the Son of Man will appear in the sky, and then all the tribes of the earth will mourn, and they will see the Son of Man

coming on the clouds of the sky with power and great glory.” Matthew 24:29–30

The implication is that the readers of Matthew's Gospel would understand what he meant by the word *sign*. Thus the word *sign* connects this event with a key Old Testament prophecy:

> *All you inhabitants of the world and dwellers on earth, as soon as a standard is raised on the mountains, you will see it, and as soon as the trumpet is blown, you will hear it. For thus the LORD has told me, “I will look from My dwelling place quietly like dazzling heat in the sunshine, like a cloud of dew in the heat of harvest.”* Isaiah 18:3–4

The prophet Isaiah is painting a vivid word picture of the New Jerusalem's appearance. The entire earth can somehow see God's dwelling place, referred to as a standard or sign, and the Lord is in it, looking down most likely from the very top.[1]

THE WORLD'S RESPONSE

The sudden appearance of the Lord Jesus Christ and His city will produce two completely opposite reactions, absolute terror in some and ecstatic joy in others. Isaiah tells us why this event will produce these contrasting emotions. The Lord is bringing not only a reward but also recompense or judgment.

> *Behold, the Lord GOD will come with might, with His arm ruling for Him. Behold, His reward is with Him and His recompense before Him.* Isaiah 40:10

When the sky is rolled back as a scroll, some on earth will be filled with joy. We also see that the appearance of the Lord is connected with reference to a mountain.

> *They raise their voices, they shout for joy; They cry out from the west concerning the majesty of the LORD. … From the ends of the earth we hear songs, “Glory to the Righteous One….”* Isaiah 24:14, 16

> *And it will be said in that day, “Behold, this is our God for whom we have waited that He might save us. This is the LORD for whom we have waited; let us rejoice and be glad in His salvation.” For the hand of the LORD will rest on this mountain….* Isaiah 25:9–10

Isaiah beautifully ties the arrival of the Lord to the city of Zion, Jerusalem:

> *“Therefore My people shall know My name; therefore in that day I am the one who is speaking, ‘Here I am.’” How lovely on the mountains are the feet of him who brings good news … and says to Zion, “Your God reigns!” Listen! Your*

watchmen lift up their voices, they shout joyfully together; for they will see with their own eyes when the LORD restores Zion. Isaiah 52:6–8

Each individual person on earth will respond according to the state of their soul, whether they are right with God or not. We see these contrasts in Psalm 48. While some are responding with joy, others are filled with horror.

Great is the LORD and greatly to be praised in the city of our God! His holy mountain, beautiful in elevation, is the joy of all the earth, Mount Zion, in the far north, the city of the great King. ... For behold, the kings assembled; they came on together. As soon as they saw it, they were astounded; they were in panic; they took to flight. Trembling took hold of them there, anguish as of a woman in labor. Psalm 48:1–2, 4–6 (ESV)

The *it* referred to in "they saw it" is the city that will bring joy to all the earth, the New Jerusalem. In other words, "as soon as they saw it" means that for some the city's appearance in the sky caused trembling and panic.

PUZZLE PIECES FALL INTO PLACE

Putting all this together, the overall sequence of events portrays striking contrasts. First darkness, then the sky rolls back as a scroll, revealing not only the Lord but the New Jerusalem as well. Rejoicing bursts forth from those who have repented and turned to the Lord. Terror strikes the hearts of the unrepentant, and rightfully so. The wrath of God is about to be unleashed upon them. The trumpet judgments sound then loud voices in heaven proclaim the arrival of God's Kingdom.

... "The kingdom of the world has become the kingdom of our Lord and of His Christ; and He will reign forever and ever." ... "We give You thanks, O Lord God, the Almighty, who are and who were, because You have taken Your great power and have begun to reign." Revelation 11:15, 17

With increasing intensity seven trumpet judgments are followed by seven bowl judgments. All of this is similar to when Solomon became king and his first act was to destroy his enemies. The last bowl judgment will be the greatest earthquake ever, setting off catastrophic topographical changes all over the earth (Revelation 16:17–18). These changes, discussed previously, prepare the earth for the landing of God's city.

"Let every valley be lifted up, and every mountain and hill be made low; and let the rough ground become a plain, and the rugged terrain a broad valley; Then the glory of the LORD will be revealed, and all flesh will see it together; for the mouth of the LORD has spoken." ... Get yourself up on a high mountain, O Zion, bearer of good news, lift

up your voice mightily, O Jerusalem, bearer of good news; lift it up, do not fear. Say to the cities of Judah, "Here is your God!" Isaiah 40:4–5, 9

For behold, the LORD is coming forth from His place. He will come down and tread on the high places of the earth. The mountains will melt under Him and the valleys will be split, like wax before the fire, like water poured down a steep place. Micah 1:3–4

After his enemies were defeated, Solomon built not only his house but also a magnificent temple. Similarly, God, after His judgments, will set down His home on earth. A beautiful final temple will be built as well.

TIMETABLES MATCH UP

In two separate sections Isaiah gives us a sequential prophecy of end time events that reinforces this timing. The first section is in chapter 2:

1. After topographical changes occur, the New Jerusalem connects with the earth.

Now it will come about that in the last days the mountain of the house of the LORD will be established as the chief of the mountains, and will be raised above the hills.... Isaiah 2:2

2. During the first 1,000 years of the Kingdom, nations come to Christ's capital to learn about the Lord.

... And all the nations will stream to it. And many peoples will come and say, "Come, let us go up to the mountain of the LORD, to the house of the God of Jacob; that He may teach us concerning His ways and that we may walk in His paths." For the law will go forth from Zion and the word of the LORD from Jerusalem. Isaiah 2:2–3

3. At the end of the first 1,000 years, Satan and the unbelieving nations will have their last uprising with God, bringing judgment upon them. God judges the dead at the Great White Throne (Revelation 20:9–15).

And He will judge between the nations, and will render decisions for many peoples.... Isaiah 2:4

4. Then everlasting peace will be enjoyed.

... And they will hammer their swords into plowshares and their spears into pruning hooks. Nation will not lift up sword against nation, and never again will they learn war. Isaiah 2:4

After this overview, Isaiah backs up and gives detail. The following couplet is repeated three times: "the terror of the Lord and the splendor of His majesty" (Isaiah 2:10, 19, 21). It is in-

terspersed with "in that day" (vv. 11, 17, 20). This, along with the following verse, implies the simultaneous occurrence of the beginning of God's wrath and the majestic appearance of not only the Lord but also His home.

> Men will go into caves of the rocks and into holes of the
> ground before the terror of the LORD and the splendor of
> His majesty.... Isaiah 2:19

Isaiah's second sequential section is in chapters 24–26. Chapter 24 begins by describing the devastation on earth due to the pouring out of the wrath of God.

> Behold, the LORD lays the earth waste, devastates it,
> distorts its surface and scatters its inhabitants. ...The earth
> will be completely laid waste and completely despoiled, for
> the LORD has spoken this word. ...All joy turns to gloom.
> The gaiety of the earth is banished. Isaiah 24:1, 3, 11

For many "all joy turns to gloom" (24:11), but for some, "They raise their voices, they shout for joy," and they even sing "concerning the majesty of the LORD" (24:14).

> They raise their voices, they shout for joy; they cry out from
> the west concerning the majesty of the LORD. ... From
> the ends of the earth we hear songs, "Glory to the Righ-
> teous One...." Isaiah 24:14, 16

1. The sky had already been rolled back at the sixth seal, exposing all of heaven, and now the greatest earthquake occurs.

> ... For the windows above are opened, and the foundations
> of the earth shake. The earth is broken asunder, the earth is
> split through, the earth is shaken violently. The earth reels
> to and fro like a drunkard and it totters like a shack....
> Isaiah 24:18–20

2. "The host of heaven on high" (Isaiah 24:21) is confined for a time and their punishment is scheduled for a later time. Again this correlates with the temporary confinement of Satan for 1,000 years and his eventual punishment as told in Revelation 20:2–3, 7, 10.

> ... The LORD will punish the host of heaven on high....
> They will be gathered together like prisoners in the dun-
> geon, and will be confined in prison; and after many days
> they will be punished. Isaiah 24:21–22

3. Then the Kingdom is begun. A unique environment will exist over Christ's capital compared to the rest of the world.

> Then the moon will be abashed and the sun ashamed, for
> the LORD of hosts will reign on Mount Zion and in Jeru-
> salem, and His glory will be before His elders. Isaiah 24:23

4. There is great rejoicing and celebrating in Christ's capital.

The LORD of hosts will prepare a lavish banquet for all peoples on this mountain; a banquet of aged wine, choice pieces with marrow, and refined, aged wine. And on this mountain He will swallow up the covering which is over all peoples, even the veil which is stretched over all nations. He will swallow up death for all time, and the Lord GOD will wipe tears away from all faces, and He will remove the reproach of His people from all the earth; for the LORD has spoken. And it will be said in that day, "Behold, this is our God for whom we have waited that He might save us. This is the LORD for whom we have waited; let us rejoice and be glad in His salvation." For the hand of the LORD will rest on this mountain. Isaiah 25:6–10a

(Note that death being swallowed up for all time is between the last two occurrences of the phrase "on this mountain." In other words, those on God's mountain have obtained immortality.)

5. God's people are grateful for the security of their new capital city.

In that day this song will be sung in the land of Judah: "We have a strong city; He sets up walls and ramparts for security." Isaiah 26:1

6. Only the immortals who are saved are allowed access in and out of this capital city.

"Open the gates, that the righteous nation may enter, the one that remains faithful." Isaiah 26:2

7. This city is the New Jerusalem (Revelation 21:2). It has come from above but is now touching the earth. It was formerly invisible to mortals but is now visible. The saints who dwelt on high have now been joined by those recently raptured.[2]

For He bringeth down them that dwell on high; the lofty city, he layeth it low; he layeth it low, even to the ground; he bringeth it even to the dust. The foot shall tread it down, even the feet of the poor, and the steps of the needy. Isaiah 26:5–6 (KJV)

8. After the first 1,000 years, the enemies of the Lord, Satan and his followers, try one last uprising. They are destroyed by fire, and the Great White Throne judgment occurs (Revelation 20:9–15).

O LORD, Your hand is lifted up yet they do not see it. They see Your zeal for the people and are put to shame; indeed, fire will devour Your enemies. … The dead will not

*live, the departed spirits will not rise; therefore You have
punished and destroyed them, and You have wiped out all
remembrance of them.* Isaiah 26:11, 14

DIFFICULTIES ADDRESSED

The most well known passage that describes the New Jerusalem descending is at the end of the New Testament in the book of Revelation.

> *And I saw the holy city, new Jerusalem, coming down out
> of heaven from God, made ready as a bride adorned for her
> husband.* Revelation 21:2

Many have understood Revelation 20–22 to be a sequential chronology. However, imbedded in the section (chapters 20–22) is a reference to mortal people with sin outside the gates of the New Jerusalem; "nothing unclean, and no one who practices abomination and lying, shall ever come into it, but only those whose names are written in the Lamb's book of life" (Revelation 21:27). This lends weight to the idea that the city is on earth during the first 1,000 years of Christ's Kingdom. Also, the descent of the New Jerusalem seems to be connected in time with the last bowl judgment. The angel who shows John the New Jerusalem "had the seven bowls full of the seven last plagues."

> *Then one of the seven angels who had the seven bowls full
> of the seven last plagues came and spoke with me, saying,*

> *"Come here, I will show you the bride, the wife of the Lamb."
> And he carried me away in the Spirit to a great and high
> mountain, and showed me the holy city, Jerusalem, coming
> down out of heaven from God.* Revelation 21:9–10

In addition, John's mention of the new heaven and the new earth (Revelation 21:1) along with the descent of the new Jerusalem (v. 2) is immediately followed with the statement that God will now be dwelling with people (v. 3).

> *And I heard a loud voice from the throne, saying, "Behold,
> the tabernacle of God is among men, and He will dwell
> among them, and they shall be His people, and God Himself will be among them."* Revelation 21:3

Old Testament prophets repeatedly said that God will dwell with people starting at the beginning of His kingdom. John's wording echoes these promises.

> *"Sing for joy and be glad, O daughter of Zion; for behold
> I am coming and I will dwell in your midst," declares
> the LORD. "Many nations will join themselves to the
> LORD in that day and will become My people. Then I
> will dwell in your midst…. The LORD will possess Judah
> as His portion in the holy land, and will again choose
> Jerusalem. Be silent, all flesh, before the LORD; for He is
> aroused from His holy habitation."* Zechariah 2:10–12

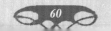

The name of the city
from that day shall be,
'The LORD
is there.'
Ezekiel 48:35

ISAIAH: They will call you **the city of the LORD.** The Zion of the Holy One of Israel Isaiah 60:14	**JOHN:** And I saw **the holy city**, new Jerusalem coming down out of heaven from God. Revelation 21:2
Nations will come to your light and kings to the brightness of your rising. Isaiah 60:3	The nations will walk by its light and the kings of the earth will bring their glory into it... they will bring the glory and the honor of the nations into it. Revelation 21:24-26
Your gates will be open continually; they will not be closed day or night. Isaiah 60:11	and its gates will never be shut by day--and there will be no night there. Revelation 21:25
Instead of bronze I will bring gold and instead of iron I will bring silver. Isaiah 60:17	The city was pure gold like clear glass. Revelation 21:18
Violence will not be heard again in your land, nor devastation or destruction with in your borders Isaiah 60:18	Outside are the dogs and the sorcerers and the immoral persons and the murderers and the idolators, and everyone who loves and practices lying. Revelation 22:15
No longer will you have the sun for light by day, nor for brightness will the moon give you light; but you will have the LORD for an everlasting light, and your God for your glory. Isaiah 60:19	And the city has no need of the sun or of the moon to shine on it, for the glory of God has illumined it, and its lamp is the Lamb. Revelation 21:23
As the bridegroom rejoices over the bride, so your God will rejoice over you. Isaiah 62:10	Come here, I will show you the bride, the wife of the Lamb. Revelation 21:9
Go through, go through the gates, clear the way for the people Isaiah 62:10	Blessed are those who wash their robes, so that they may enter by the gates into the city. Revelation 22:14
Behold, His reward is with Him. Isaiah 62:11	Behold, I am coming quickly, and My reward is with Me. Revelation 22:12
For behold, I create new heavens and a new earth... for behold, I create Jerusalem for rejoicing. Isaiah 65:17	Then I saw a new heaven and a new earth... and I saw the holy city, new Jerusalem, coming down out of heaven from God Revelation 21:1, 2
There will no longer be heard in her the voice of weeping and the sound of crying. Isaiah 65:19	...there will no longer be any...crying. Revelation 21:4
As one whom his mother comforts, so will I comfort you; and you will be comforted in Jerusalem. Isaiah 65:25	...and He will wipe away every tear from their eyes. Revelation 21:4
They will do no evil or harm in all My holy mountain. Isaiah 65:25	...and there will no longer be any death (within the city) Revelation 21:4
Then they will go forth (outside the city) and look on the corpses of the men who have transgressed against Me. Isaiah 66:24	But for the cowardly and unbelieving and abominable and murderers and immoral persons and sorcerers and idolators and all liars, their part will be in the lake that burns with fire and brimstone, which is the second death. Revelation 21:8

The prophecy of Ezekiel repeats and expands this promise. The face to face fellowship of Eden will not just be restored, but be permanently restored. Speaking of the Holy Allotment city, he says: "The name of the city from that day shall be, 'The LORD is there.'"

As we have seen, many Old and New Testament prophecies are beautifully and logically harmonized with God's home, the New Jerusalem landed on earth. Thus, it is the author's opinion that the weight of evidence should be our guide.

GOD'S PERMANENT PLAN

The capital city, New Jerusalem, is only one part of the larger permanent plan of God. As the Holy City lands, the entire earth and its atmosphere will be restored to the perfect condition Adam and Eve once enjoyed. John and Isaiah each give descriptions of this that harmonize beautifully with each other. They talk of the New Jerusalem along with a new heaven and a new earth all in the same context. It should be noted that Jewish scholars in general down through history have believed that when Messiah comes, the New Jerusalem that "was created by God to house the souls of the righteous" will "be realized in the Millennial era yet continue into the final age, the World to Come."[4]

We have already seen how the arrival of Jesus Christ is connected with the arrival of His city and now we see His city connected with the new heavens and the new earth. In the New Testament, Peter connects the new heaven and the new earth with Christ's coming. He talks about how Jesus will come at the time "of restoration of all things about which God spoke by the mouth of His holy prophets from ancient time" (Acts 3:21).[5]

This is consistent with many prophecies that say that once Christ's Kingdom is begun, it will be forever.

> "In the days of those kings the God of heaven will set up a kingdom which will never be destroyed, and that kingdom will not be left for another people; it will crush and put an end to all these kingdoms, but it will itself endure forever." Daniel 2:44

> "... [The Son of Man's] kingdom is one which will not be destroyed." Daniel 7:14

> "... You shall name Him Jesus. ... And He will reign over the house of Jacob forever, and His kingdom will have no end." Luke 1:31b, 33

This view is strengthened further by the prophecies that link Christ's permanent Kingdom directly to the land of Israel.

> The covenant which He made with Abraham, and His oath to Isaac. Then He confirmed it to Jacob for a statute, to Israel as an everlasting covenant, saying, "To you I will

give the land of Canaan as the portion of your inheritance." Psalm 105:9–11

But Judah will be inhabited forever and Jerusalem for all generations. Joel 3:20

"*They will live on the land that I gave to Jacob My servant, in which your fathers lived; and they will live on it, they, and their sons and their sons' sons, forever; and David My servant will be their prince forever.*" Ezekiel 37:25

For the LORD has chosen Zion; He has desired it for His habitation. "This is My resting place forever; Here I will dwell, for I have desired it." Psalm 132:13–14

Although there are references that talk of the earth perishing, upon close examination they do not mean total destruction of the planet itself but only things on the surface of the earth. All references in Revelation of destruction by fire during the trumpet and bowl judgments are partial, with the actual fractions given (Revelation 8:7; 9:18). A parallel passage in Zechariah tells of fractions of the population surviving (Zechariah 13:8–9).

There is a judgment by fire upon Satan and those who follow him at the end of the first thousand years of the Kingdom, but it is not a destruction of the planet. The fire is directed upon only the attackers.

And they came up on the broad plain of the earth and surrounded the camp of the saints and the beloved city, and fire came down from heaven and devoured them. Revelation 20:9

All this is reinforced by the language of the Psalms.[6]

[God] laid the foundations of the earth, that it should not be removed for ever. Psalm 104:5 (KJV)

[God] chose the tribe of Judah, Mount Zion which He loved. And He built His sanctuary like the heights, like the earth which He has founded forever. Psalm 78:68–69

Say among the nations, "The LORD reigns; indeed, the world is firmly established, it will not be moved; He will judge the peoples with equity." Psalm 96:10

Praise Him, sun and moon; praise Him, all stars of light! … For He commanded and they were created. He has also established them forever and ever; He has made a decree which will not pass away. Psalm 148:3, 5–6

Thus, we conclude that the permanent plan of God is a permanent earth. Though He brings judgment, He will return to live among us, bringing His house with Him to a restored planet.

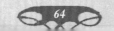

"… I am God, and there is no one like Me, … 'My purpose will be established, and I will accomplish all My good pleasure.'" Isaiah 46:9–10

… He is the God who formed the earth and made it, He established it and did not create it a waste place, but formed it to be inhabited…. Isaiah 45:18

A MATERIAL MANIFESTATION OF GOD'S GRACE

Now let us step back and see how all this fits in with the big picture. If we view the panorama of time that God has given us starting with Genesis and culminating with Revelation, we see in the past that God destroyed things on the surface of the earth by water and catastrophic changes, followed by a restoration. In the future, during the Day of the Lord, He will destroy things on the surface of the earth with fire and catastrophic changes. This is the ultimate Judgment of those who reject His gracious provision of salvation (Revelation 20:11–15).

But God does not finish the Bible with this scene. Rather than ending on a negative, He ends on a positive. He backs up and gives us the details of the most breathtaking miracle event of all, as Christ appears with His Holy City, "the joy of the whole earth" (Psalm 48:2). This will be the visual symbol of God's incredible grace as He stoops to live permanently with us.

God has in the past allowed whole groups of humans to see some spectacular miracle events. Joshua and his army saw the sun stand still. The Israelites saw the Red Sea open before them. Christ's disciples saw Him lifted up into the clouds right before their eyes. However, the descent of the city of the New Jerusalem will defy description. We know that manmade structures are ultimately fragile. Even those set upon a firm foundation can be brought down in mere moments by an earthquake, or tragically by jet planes. Thus, house moving is a tense but amazing thing to watch. But in this case, we are talking about "the city which has foundations, whose architect and builder is God" coming down out of the sky (Hebrews 11:10).

I am the LORD,
that is My name…
Behold, the former things have come to pass,
now I declare new things;
before they spring forth
I proclaim them to you.

ISAIAH 42:8, 9

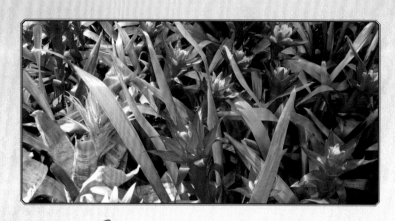

HE IS THE GOD WHO FORMED THE EARTH
AND MADE IT, HE ESTABLISHED IT AND
DID NOT CREATE IT A WASTE PLACE, BUT
FORMED IT TO BE INHABITED.
ISAIAH 45:18

chapter six
DELIGHTING IN THE DETAILS

THE BIG PICTURE IS IN place. Now the previous conclusions about the New Jerusalem's location, size, shape, and timing form a foundation to build upon. If these ideas are correct, a detailed examination of the city's specific characteristics will harmonize and confirm those conclusions. As we look at these details we will also see that the city is delightfully livable and personal.

THE WATER OF LIFE

To begin with, God's entire capital complex will be well watered. Six different prophets give us information about a life-sustaining water supply. Starting at the source and working our way outward, we will get the full picture of this magnificent system. John tells us how his angel escort showed him the very source, "a river of the water of life, clear as crystal, coming from the throne of God" (Revelation 22:1). From God's throne at the pinnacle of the city structure this river branches out and down throughout the city. "There is a river whose streams make glad the city of God, the holy dwelling places of the Most High" (Psalm 46:4). Isaiah says that either these

rivers and wide canals are not used for transportation, or only vessels such as sail boats are permitted. Certainly, God paints a picture of secure, serene beauty.

> *Look upon Zion, the city of our appointed feasts; your eyes will see Jerusalem, an undisturbed habitation, a tent which will not be folded; its stakes will never be pulled up, nor any of its cords be torn apart. But there the majestic One, the LORD, will be for us a place of rivers and wide canals on which no boat with oars will go, and on which no mighty ship will pass.* Isaiah 33:20–21

The water flows out of the city toward the temple in the Holy Allotment. Ezekiel gives a detailed description of this. He says his angel escort brought him "back to the door of the house [here the word *house* means the temple]; and behold, water was flowing from under the threshold of the house toward the east, for the house faced east. And the water was flowing down from under, from the right side of the house, from south of the altar" (Ezekiel 47:1). From Ezekiel's point of view when he

67

was standing at the door of the temple the water was "flowing … from the right side of the house, from south of the altar." According to Ezekiel's plan of the Holy Allotment, the temple faces east, and the city would be south of the temple. If the water source is the throne of God in the city, it would flow north to the temple then outward from under the temple porch east.

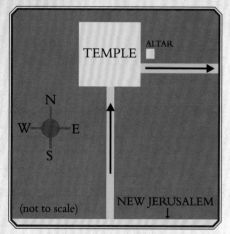

TEMPLE
ALTAR
N
W E
S
(not to scale)
NEW JERUSALEM

Furthermore we learn from Zechariah that the water flows out of the greater metropolitan area of Jerusalem both eastward and westward. "And in that day living waters will flow out of Jerusalem, half of them toward the eastern sea and the other half toward the western sea; it will be in summer as well as in winter" (Zechariah 14:8). In other words, this river from the temple eventually branches into waterfalls off the sides of the plateau. Joel beautifully describes this future scene.

Then you will know that I am the LORD your God, dwelling in Zion, My holy mountain. So Jerusalem will be holy, and strangers will pass through it no more. And in

that day the mountains will drip with sweet wine, and the hills will flow with milk, and all the brooks of Judah will flow with water; and a spring will go out from the house of the LORD to water the valley of Shittim. Joel 3:17–18

It is important to note that the phrase "water of life" (Revelation 22:1) doesn't mean that by drinking the water one would live forever as with the Tree of Life. It most likely refers to the fact that the water has health-giving properties. After the destruction of the world's water supply during the Tribulation, restoration will be vital for the earth's surviving mortals (Revelation 16:3–4).

Ezekiel describes how the tributaries of this river will branch out throughout the Promised Land and names known places that have evidently survived the great topographical changes of the trumpet and bowl judgments: the valley of Shittim, Arabah, Engedi, and Eneglaim.

Then he said to me, "These waters go out toward the eastern region and go down into the Arabah; then they go toward the sea, being made to flow into the sea, and the waters of the sea become fresh. It will come about that every living creature which swarms in every place where the river goes, will live. And there will be very many fish, for these waters go there and the others become fresh; so everything will live where the river goes. And it will come about that fishermen will stand beside it; from Engedi to

Eneglaim there will be a place for the spreading of nets. Their fish will be according to their kinds, like the fish of the Great Sea, very many. But its swamps and marshes will not become fresh; they will be left for salt. By the river on its bank, on one side and on the other, will grow all kinds of trees for food. Their leaves will not wither and their fruit will not fail. They will bear every month because their water flows from the sanctuary, and their fruit will be for food and their leaves for healing." Ezekiel 47:8–12

A lush green shore will surround the former Dead Sea. Cleansed and teaming with a great variety of fish, the water will lure those who spread their nets. The Sea that was once dead, will be a fisherman's dream.

THE HEAVENLY FIELDS

The end result helps produce lush vegetation not only for God's capital but for the entire Promised Land. Food will be plenteous, and flowers abundant! Over and over again God vividly describes scenes of agricultural prosperity that are meant to encourage and give us hope.

The wilderness and the desert will be glad, and the Arabah will rejoice and blossom; like the crocus it will blossom profusely.... Isaiah 35:1–2

Indeed, the LORD will comfort Zion; He will comfort all her waste places and her wilderness He will make like Eden, and her desert like the garden of the LORD; joy and gladness will be found in her, thanksgiving and sound of a melody. "Pay attention to Me, O My people, and give ear to Me, O My nation...." Isaiah 51:3–4

In addition, since great ocean valleys will be raised and mountains lowered during the last bowl judgment (Isaiah 40:4–5), the huge oceans of the world will be altered and probably will become smaller and more numerous. Nevertheless, some of these bodies of water will still be fairly large because Isaiah talks of ships being used: "and the ships of Tarshish will come first, to bring your sons from afar" (Isaiah 60:9).

The flatter terrain makes it easier to build towns and villages interspersed with fertile soil and good pasture land for livestock. God through His prophets repeatedly paints pictures for us in rich detail.

"Behold, days are coming," declares the LORD, "when the plowman will overtake the reaper and the treader of grapes him who sows seed; when the mountains will drip sweet wine and all the hills will be dissolved. Also I will

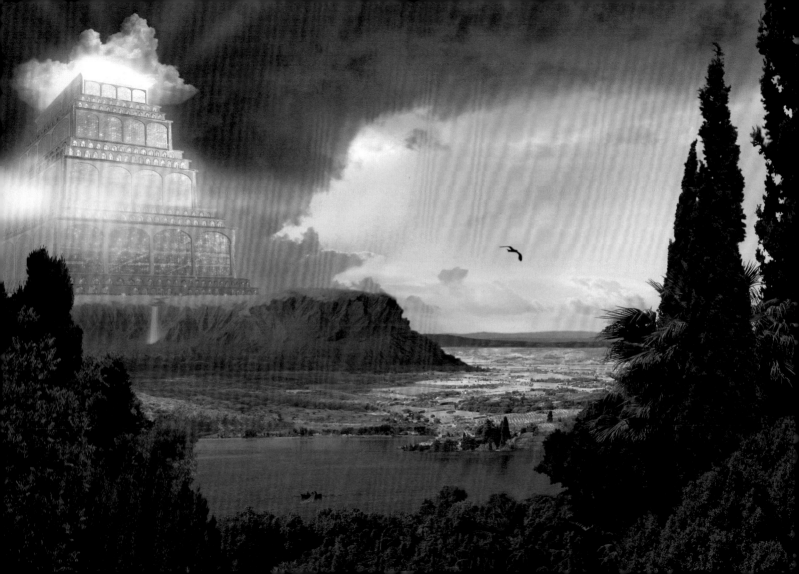

restore the captivity of My people Israel, and they will rebuild the ruined cities and live in them; they will also plant vineyards and drink their wine, and make gardens and eat their fruit. I will also plant them on their land, and they will not again be rooted out from their land which I have given them," says the LORD your God. Amos 9:13–15

"I will establish for them a renowned planting place, and they will not again be victims of famine in the land, and they will not endure the insults of the nations anymore." Ezekiel 34:29

Then He will give you rain for the seed which you will sow in the ground, and bread from the yield of the ground, and it will be rich and plenteous; on that day your livestock will graze in a roomy pasture. Isaiah 30:23

Thus says the LORD of hosts, the God of Israel: "Once more they shall use these words in the land of Judah and in its cities, when I restore their fortunes: 'The LORD bless you, O habitation of righteousness, O holy hill!' And Judah and all its cities shall dwell there together, and the farmers and those who wander with their flocks." Jeremiah 31:23–24 (ESV)

GETTING AROUND

As benefits and blessings flow out from God's city through the river of the water of life, so also will God supply highways to bring people in to the Holy Allotment. Isaiah tells us about these highways within the land promised to Abraham (Genesis 15:18). We can see how they will stretch from the River of Egypt to the Euphrates.

And there will be a highway from Assyria for the remnant of His people who will be left, just as there was for Israel in the day that they came up out of the land of Egypt. Isaiah 11:16

In that day there will be a highway from Egypt to Assyria, and the Assyrians will come into Egypt and the Egyptians into Assyria, and the Egyptians will worship with the Assyrians. Isaiah 19:23

Isaiah describes a special road that is probably in the protected areas under the canopy.

… [God will] "restore the land, to make them inherit the desolate heritages.…Along the roads they will feed, and their pasture will be on all bare heights. They will not hunger or thirst, nor will the scorching heat or sun strike them down; for He who has compassion on them will lead them and will guide them to springs of water. I will make all My mountains a road, and My highways will be raised up." Isaiah 49:8–11

If the New Jerusalem is in the shape of a step pyramid, God might be talking about the accessibility of the different levels. Isaiah also refers to a road that is exclusively for the redeemed. This sounds like a particular road that is within the New Jerusalem.

> *A highway will be there, a roadway, and it will be called the Highway of Holiness. The unclean will not travel on it, but it will be for him who walks that way, and fools will not wander on it. No lion will be there, nor will any vicious beast go up on it; these will not be found there but the redeemed will walk there, and the ransomed of the LORD will return and come with joyful shouting to Zion, with everlasting joy upon their heads. They will find gladness and joy, and sorrow and sighing will flee away. Isaiah 35:8–10*

Ezekiel also describes an area where there is a different degree of protection and where there will be relatively good weather, yet rain is allowed.

> *"I will make them [the Israelites] and the places around My hill a blessing. And I will cause showers to come down in their season; they will be showers of blessing. Also the tree of the field will yield its fruit and the earth will yield its increase, and they will be secure on their land...." Ezekiel 34:26–27*

This is probably referring to the entire land promised to Abraham where mortals would dwell. Since there will be varying degrees of protection, we might define these regions as a Holy Zone within a Safe Zone. The following verses could be describing these zones.

> *Violence shall no more be heard in thy land wasting nor destruction within thy borders; but thou shalt call thy walls Salvation, and thy gates Praise. Isaiah 60:18 (KJV)*

> *And in that day will I make a covenant for them with the beasts of the field, and with the fowls of heaven, and with the creeping things of the ground: and I will break the bow and the sword and the battle out of the earth, and will make them to lie down safely. Hosea 2:18 (KJV)*

> *Then you will know that I am the LORD your God, dwelling in Zion, My holy mountain. So Jerusalem will be holy, and strangers will pass through it no more. Joel 3:17*

WE SHALL WEAR A CROWN

During the first 1,000 years of Christ's Kingdom, the resurrected immortals will be not only in the New Jerusalem but out and about, ruling and reigning with Christ in a world that still has mortals. If this idea of mortals and immortals intermingling seems difficult to imagine, we can keep in mind the following:

1. Jesus gave us an example of this when He spoke as well as ate with mortals after His resurrection.
2. God tells us that this condition is temporary, lasting for 1,000 years.
3. Christ, as Head over all, will rule with a rod of iron. Though hearts may still choose to be independent of God, perfect justice will be administered promptly, restraining the actions of people.
4. The resurrected immortals will finally have rest from their biggest battle. They will by God's grace have conquered personal sin.

The following verse might have both a near and a far fulfillment, referring to a special protection as we go out to serve the Lord among the mortal inhabitants of the world:

> Depart, depart, go out from there, touch nothing unclean;
> go out of the midst of her, purify yourselves, you who carry
> the vessels of the LORD. But you will not go out in haste,
> nor will you go as fugitives; for the LORD will go before
> you, and the God of Israel will be your rear guard.
> Isaiah 52:11–12

Some interesting verses relate the fact that some Gentile mortals will be servants to either Israelite mortals or the redeemed immortals.

> When the LORD will have compassion on Jacob and
> again choose Israel, and settle them in their own land, then
> strangers will join them and attach themselves to the house
> of Jacob. The peoples will take them along and bring them
> to their place, and the house of Israel will possess them as
> an inheritance in the land of the LORD as male servants
> and female servants; and they will take their captors captive
> and will rule over their oppressors. Isaiah 14:1–2

> "Foreigners will build up your walls, and their kings will
> minister to you; for in My wrath I struck you, and in My
> favor I have had compassion on you." Isaiah 60:10

> Strangers will stand and pasture your flocks, and foreigners
> will be your farmers and your vinedressers. Isaiah 61:5

It is very interesting that God specifically mentions children. The prophet Zechariah gives a vivid and heartwarming description that includes old men and old women as well as children in Jerusalem.

> Thus says the LORD, "I will return to Zion and will dwell
> in the midst of Jerusalem. Then Jerusalem will be called the
> City of Truth, and the mountain of the LORD of hosts will
> be called the Holy Mountain." Thus says the LORD of
> hosts, "Old men and old women will again sit in the streets
> of Jerusalem, each man with his staff in his hand because of

age. And the streets of the city will be filled with boys and girls playing in its streets." Zechariah 8:3–5

This verse presents difficulties unless the term *Jerusalem* in this case is being used in its larger meaning, as the capital of the world. The young and old would then be referring to the mortals that live around the base of the New Jerusalem in the Holy Allotment or in the entire Promised Land. In the rest of these verses, it is difficult to tell whether some or all of these refer to resurrected children or to mortal Israelite descendants. Nevertheless, they powerfully speak of God's love for children and his compassion for parents.

"The children of whom you were bereaved will yet say in your ears, 'The place is too cramped for me; make room for me that I may live here.' Then you will say in your heart, 'Who has begotten these for me, since I have been bereaved of my children and am barren, an exile and a wanderer? And who has reared these? Behold, I was left alone; from where did these come?'" Thus says the Lord GOD, "Behold, I will lift up My hand to the nations and set up My standard to the peoples; and they will bring your sons in their bosom, and your daughters will be carried on their shoulders." Isaiah 49:20–22

Thus says the LORD, "A voice is heard in Ramah, lamentation and bitter weeping. Rachel is weeping for her children; she refuses to be comforted for her children, because they are no more." Thus says the LORD, "Restrain your voice from weeping and your eyes from tears; for your work will be rewarded," declares the LORD, "and they will return from the land of the enemy. There is hope for your future," declares the LORD, "and your children will return to their own territory." Jeremiah 31:15–17

"I will whistle for them to gather them together, for I have redeemed them; and they will be as numerous as they were before. When I scatter them among the peoples, they will remember Me in far countries, and they with their children will live and come back." Zechariah 10:8–9

But Jesus said, "Let the children alone, and do not hinder them from coming to Me; for the kingdom of heaven belongs to such as these." Matthew 19:14

PEOPLE WILL COME

For mortals, there will be a brand new system of worship, as shown to us by Ezekiel. It seems to be a blend of certain aspects of the Mosaic system and the Church Age. The Ark of the Cov-

enant won't be present, but there will be animal sacrifices. These sacrifices will visually demonstrate faith, remembering and memorializing Christ's sacrifice on the cross (Hebrews 10:1–4.)[1] Mortals then will have the opportunity to worship God out in front of the New Jerusalem, at the temple, but will not have access to the Golden City itself.

> Also the foreigners who join themselves to the LORD, to minister to Him, and to love the name of the LORD, to be His servants, every one who keeps from profaning the sabbath and holds fast My covenant; even those I will bring to My holy mountain and make them joyful in My house of prayer. Their burnt offerings and their sacrifices will be acceptable on My altar; for My house will be called a house of prayer for all the peoples. Isaiah 56:6–7

> "And it shall be from new moon to new moon and from sabbath to sabbath, all mankind will come to bow down before Me," says the LORD. Isaiah 66:23

> And He said to me, "Son of man, thus says the Lord GOD, 'These are the statutes for the altar on the day it is built, to offer burnt offerings on it and to sprinkle blood on it. …When they have completed the days, it shall be that on the eighth day and onward, the priests shall offer your burnt offerings on the altar, and your

> peace offerings; and I will accept you,' declares the Lord God." Ezekiel 43:18, 27

> "Thus says the LORD of hosts, 'It will yet be that peoples will come, even the inhabitants of many cities. The inhabitants of one will go to another, saying, "Let us go at once to entreat the favor of the LORD.…"' Thus says the LORD of hosts, 'In those days ten men from all the nations will grasp the garment of a Jew, saying, "Let us go with you, for we have heard that God is with you."'" Zechariah 8:20–21, 23

Isaiah tells us that animals will be herbivores. It is possible that this applies to the entire earth; however, the immediate context refers only to God's "holy mountain." This could mean the entire Holy Allotment or just the New Jerusalem. In addition, these verses do not specifically say that animal sacrifices could not be possible. They merely say that animals will not harm people.

> And the wolf will dwell with the lamb, and the leopard will lie down with the young goat, and the calf and the young lion and the fatling together; and a little boy will lead them. Also the cow and the bear will graze, their young will lie down together, and the lion will eat straw like the ox. The nursing child will play by the hole of the cobra, and the weaned child will put his hand on the viper's den. They

*will not hurt or destroy in all My holy mountain, for the
earth will be full of the knowledge of the LORD as the
waters cover the sea.* Isaiah 11:6–9

*"The wolf and the lamb will graze together, and the lion
will eat straw like the ox; and dust will be the serpent's
food. They will do no evil or harm in all My holy moun-
tain," says the LORD.* Isaiah 65:25

*"In that day I will also make a covenant for them with the
beasts of the field, the birds of the sky and the creeping
things of the ground. And I will abolish the bow, the sword
and war from the land, and will make them lie down in
safety."* Hosea 2:18

THROUGH GATES OF SPLENDOR

The surrounding countryside is but the frame for the beau-
tiful city of Zion. How fortunate we are that John carefully
recorded for us the wonder standing before his eyes. He saw
"the holy city, Jerusalem, coming down out of heaven from
God, having the glory of God. Her brilliance was like a very
costly stone, as a stone of crystal-clear jasper" (Revelation
21:10–11). We can imagine as his gaze swept across its great
high wall with its majestic gates standing open that he noted
the angelic sentinels that were posted. Each gateway was made
of one massive pearl and marked with a name. One had the
word "Praise," one said "Justice," and one even said "Wres-
tling." Though these are translated for us into English, John
knew them as the names of the tribes of Israel. This is predict-
ed by Isaiah when he says, "You will call your walls salvation,
and your gates praise" (Isaiah 60:18). Isaiah had these gates of
splendor in mind when he penned the following words: "We
have a strong city; he sets up walls and ramparts for security.
Open the gates, that the righteous nation may enter" (Isaiah
26:1–2). Ezekiel, too, describes the walls with 12 gates, 3 on
each side. He even designates which of the gate names is on
each side![2]

*"These are the exits of the city: on the north side, 4,500
cubits by measurement, shall be the gates of the city,
named for the tribes of Israel, three gates toward the
north: the gate of Reuben, one; the gate of Judah, one;
the gate of Levi, one. On the east side, 4,500 cubits,
shall be three gates: the gate of Joseph, one; the gate of
Benjamin, one; the gate of Dan, one. On the south side,
4,500 cubits by measurement, shall be three gates: the
gate of Simeon, one; the gate of Issachar, one; the gate of
Zebulun, one. On the west side, 4,500 cubits, shall be
three gates: the gate of Gad, one; the gate of Asher, one;
the gate of Naphtali, one. The city shall be 18,000 cubits
round about; and the name of the city from that day shall
be, 'The LORD is there.'"* Ezekiel 48:30–35

John's description makes a point of separating the size of the city limits from the size of the wall.

And the one who spoke with me had a measuring rod of gold to measure the city and its gates and walls. The city lies foursquare, its length the same as its width. And he measured the city with his rod, 12,000 stadia. Its length and width and height are equal. He also measured its wall, 144 cubits by human measurement, which is also an angel's measurement. Revelation 21:15–17 (ESV)

The measurement given could be either the thickness of the wall or its height (216 feet). The city invites us with its gates wide open, yet the high walls emphasize security: "They will not hurt or destroy in all My holy mountain" (Isaiah 11:9). Evidently John's angel escort took him all the way around the city. The psalmist encourages us to imagine doing the same:

Walk about Zion and go around her; count her towers; consider her ramparts; go through her palaces, that you may tell it to the next generation. For such is God, Our God forever and ever; He will guide us until death. Psalm 48:12–14

GLORIOUS THINGS OF THEE ARE SPOKEN

If we could walk in Jerusalem just like John, we would see the glory and the beauty his privileged eyes beheld. The New Jerusalem's "brilliance was like a very costly stone, as a stone of crystal-clear jasper," and "The material of the wall was jasper; and the city was pure gold, like clear glass" (Revelation 21:11, 18). The jasper (possibly diamond-like) walls allow the light of the Lord's glory to shine from within the city outward as a beacon to the entire Promised Land. The city of gold within would radiate a warm hue similar to a pretty spring morning.[3]

Looking closer at the wall surrounding the New Jerusalem, we see that "the wall of the city had twelve foundation stones, and on them were the twelve names of the twelve apostles of the Lamb" (Revelation 21:14). John then lists twelve precious stones with specific names. "The foundation stones of the city wall were adorned with every kind of precious stone" (Revelation 21:19). Unfortunately, the exact color of some of these jewels is unknown to us today. Often museum exhibits of royal jewels show designs that seem far overdone. Earthly royalty meant to impress their followers and other kings with their wealth and power. However, God is always balanced, always measured. The word *adorned* is used in this verse in Revelation, implying a delicate beauty.[4]

The following verses could be the inspiration for a painting or animation. God compares His people with the beauty and preciousness of jewels. Thus, in addition to actual jewels, at least some of what seems like jewels (maybe from a distance), could actually be people. From far away, these "jewels" appear to shimmer! As the New Jerusalem approaches land, the Jewish mortals that accepted their Messiah on the Day of Atone-

ment could see the joyous redeemed (resurrected immortals) excitedly waving as from the portals of a ship as it arrives.

> *But Zion said, "The LORD has forsaken me, and the Lord has forgotten me. ... Lift up your eyes and look around; all of them gather together, they come to you. As I live," declares the LORD, "you will surely put on all of them as jewels and bind them on as a bride."*
> Isaiah 49:14, 18

> *And they shall be mine, saith the LORD of hosts, in that day when I make up my jewels....* Malachi 3:17 (KJV)

Stepping back now to get a broader view, we can find several references to the beauty of God's capital. Much has been written on the subject of beauty, but here are some of the things God says about it in relation to His house. The following verses seem to say that the very holiness of God contributes to its beauty.

> *The Lord reigns, He is clothed with majesty. ... Your testimonies are fully confirmed; holiness befits Your house, O LORD, forevermore.* Psalm 93:1a, 5

The Hebrew word that is used here tells us that God's idea of beauty includes being pleasant and suitable.

We also see that when it comes to structures, especially if we study the examples He has given us, symmetry and order are important to God. These include the Tabernacle in the wilderness, Solomon's Temple, and Ezekiel's detailed description of the future temple. However, the city that comes down from heaven will display the ultimate example of beauty.

> *Out of Zion, the perfection of beauty, God hath shined. Our God shall come, and shall not keep silence.* Psalm 50:2–3a (KJV)

> *You [Jerusalem] will also be a crown of beauty in the hand of the LORD, and a royal diadem in the hand of your God.* Isaiah 62:3

> *... His resting place will be glorious.* Isaiah 11:10

In the following prophecy from Isaiah, the Lord is comforting the chastised city, earthly Jerusalem, by encouraging its citizens to look ahead to the future.

> *"O afflicted one, storm-tossed, and not comforted, behold, I will set your stones in antimony, and your foundations I will lay in sapphires. Moreover, I will make your battlements of rubies, and your gates of crystal, and your entire wall of precious stones."* Isaiah 54:11–12

Interestingly, the word *antimony* means *fair colors* and comes from a root meaning *to paint*. Now until we actually see it with

our eyes, how can any human being discover what the "perfection of beauty" (Psalm 50:2) looks like? And since God is the only truly creative Being (the only One who truly creates out of nothing), how could any mortal artist illustrate such a thing? Attempting to paint the Master Painter's work without seeing it first seems presumptuous. Yet God, in His biblical descriptions, often invites us to picture His city. God seems to say "Look! Look at this! Just picture it!"

> … *"Behold, the tabernacle of God is among men…."*
> Revelation 21:3

Moreover, God has given us plenty of reference material in two important ways. We have tastes of beauty even in this sin-cursed world. First of all, He has richly supplied this earth with natural beauty. Interestingly, paintings and photos of beautiful scenery usually show high mountains, waterfalls, rivers, trees, flowers, and beautiful light effects, all of which are referred to or implied in the various references already discussed. Isaiah seems to say that there will even be greenery throughout the city (though this verse could indicate the wood of these trees being used in the exterior or interior of structures).

> *"The glory of Lebanon will come to you, the juniper,*
> *the box tree and the cypress together, to beautify the*
> *place of My sanctuary; and I shall make the place of*

> *My feet glorious. … And they will call you the city*
> *of the LORD, the Zion of the Holy One of Israel."*
> Isaiah 60:13–14

Besides natural beauty, we also can refer to manmade beauty. In spite of the curse, even what we mortals create might be giving us a taste of the future.

> *"… In the hearts of all*
> *who are skillful I have put*
> *skill…."* Exodus 31:6

Thus God's hand is upon architects, designers, engineers, artists, and craftsmen, guiding them even now. If we look back at older Disney movies showing Snow White having fun with the seven dwarfs in their cute, cozy cottage or Sleeping Beauty going off to live with the prince in his beautiful castle, we see beautiful places and happy, good people. We are drawn

to that! And that is part of what made Disney so popular. Later, the Disney team of artists and engineers, the Imagineers, had the challenge and fun of creating Disney World. One challenge they had was to be considerate of the needs of people. They had to stay within that box. The fun was having all sorts of freedom within that box. Artists who try to project what the New Jerusalem might be like have the challenge to stay within the box of Scripture. But we can have all sorts of fun within that box. Will the twelve levels be equal? Will it look like a giant skyscraper? Will it be like a Star Wars–type space station? How about a naturalistic Hobbit-like mountain? Maybe the city will include a variety of styles of architecture, representing the nations of the world and the immense diversity of personalities that God has created?

THE HAPPIEST PLACE ON EARTH

All of this leads us to the subject of really happy, really good people, the immortal inhabitants of the New Jerusalem.

> *"But be glad and rejoice forever in what I create; for behold,*
> *I create Jerusalem for rejoicing and her people for gladness.*
> *I will also rejoice in Jerusalem and be glad in My people."*
> Isaiah 65:18–19a

Now, some have pictured eternity with God as one continual worship service full of reverential solemnity. The following verse at first glance seems to imply that being in God's presence means we will be continually bowing down before the Lord, singing and praising Him forever and ever.

> *And the four living creatures, … day and night they do*
> *not cease to say, "Holy, holy, holy is the LORD God,*
> *the Almighty, who was and who is and who is to come."*
> *And when the living creatures give glory and honor and*
> *thanks to Him who sits on the throne, to Him who lives*
> *forever and ever, the twenty-four elders will fall down*
> *before Him who sits on the throne, and will worship*
> *Him who lives forever and ever, and will cast their crowns*
> *before the throne, saying, "Worthy are You, our Lord and*
> *our God, to receive glory and honor and power; for You*
> *created all things, and because of Your will they existed,*
> *and were created." Revelation 4:8–11*

However, the word *when* in verse 9 is a key. The 24 elders only bow down and cast their crowns when the creatures say their praises. In addition, later verses indicate that the creatures as well as the elders do and say other things (Revelation 5:8, 14; 15:7). More likely, this verse is saying that the creatures praise the Lord faithfully on a daily basis, morning and evening. The permanent cycles of the sun and moon would give structure to time, though they are not needed under the canopy.

Thus artwork concerning the subject of God's capital city needs to somehow communicate the incredible joy of its citi-

zens. After all, "in [His] presence is fullness of joy" (Psalm 16:11). And how precious it was when Jesus said, "Blessed are you who weep now, for you shall laugh" (Luke 6:21). Surely there will be times of serious, earnest joy or even awe-inspired, hallelujah joy as well, for being filled with the Spirit includes gratitude and singing (Ephesians 5:18–20). The prophet Zechariah helps us picture a happy family sitting around the dinner table, all laughing and joking, some even falling off their chairs with hearty laughter. God makes an amazing comparison: it's as though they are drunk with good spirits, the Holy Spirit!

> "… And their heart will be glad as if from wine; indeed, their children will see it and be glad, their heart will rejoice in the LORD." Zechariah 10:7

Again, we can look at some of Walt Disney's creations, particularly his amusement park, Disneyland. Maybe even this is giving us a taste of the future, for some have called it "the Happiest Place on Earth." Interestingly, God compares the comfort He gives in the New Jerusalem with that of a mother who distracts, amuses, and captivates the attention of her baby.

> … Then shall ye suck, ye shall be borne upon her sides, and be dandled upon her knees. As one whom his mother comforteth, so will I comfort you; and ye shall be comforted in Jerusalem. Isaiah 66:12–13 (KJV)

The word *dandled* can actually mean *to amuse*. Maybe Disney was unknowingly copying God's example in helping us forget all our troubles, for "the former things will not be remembered or come to mind" (Isaiah 65:17).

Now some may struggle with the very idea of living in a city, even if it is God's city. It is truly difficult to comprehend the perfect, sweet fellowship of human beings living in close proximity to one another, harmony without end! Cities filled with sinners in the here and now cause many to prefer country living. But harmony it will be. Neighbors will really love their neighbors! Actually, loving our neighbor is part of what it means to love God. He loves people. And if we are to be like Him, we will love people too. Of course, eagerly loving the Lord and longing for His return is paramount, but reunion and fellowship with others is part of that love: "The one who does not love his brother whom he has seen, cannot love God whom he has not seen" (I John 4:20). Then again, it will help that neighbors will be lovable! Both they (and us!)

will be able to work together in harmony and brotherly love. We will all be kindhearted, sympathetic, humble in spirit, and blessing one another (I Peter 3:8). In the light of all of this, how precious was the Old Testament expression, "he was gathered to his people" (Genesis 25:8).

A DIFFERENT KIND OF CITY LIVING

When decorating their homes, people often try to bring the outdoors in. They add live plants and flowers, fabrics with beautiful prints, and interesting textures. Even small fountains and music with the sounds of birds and crickets are used. The ever present challenge of bringing in light is helped by carefully positioned light fixtures and large windows. A ceiling fan might be added to stir up a breeze.

On the other hand, on their deck, people also bring the indoor comforts out. We sometimes see tables set with tablecloths and fine china, and comfy, cushioned chairs all around. Outdoor carpet, bug repellant candles, and awnings all help to eliminate some of the drawbacks of outdoor living. City dwellers furnish their rooftop gardens with places to cook, as well as places to sit and eat. Plexiglass shields offer protection from gusty winds, and heaters help counter colder air temperatures at the higher altitudes.

The New Jerusalem could possibly include the best of both worlds, pleasing every sense. The light of the Lord makes indoors seem like outdoors, creating the environment of a beautiful spring day everywhere. Magnificent golden structures are interconnected with pedestrian walkways on multiple levels. The structures are balanced by an abundance of living things. Besides beautiful parks and scenic walking trails, flowers, trees, and grass are abundant throughout the city. Clean, sparkling waterways are crisscrossed by decorative foot bridges in smaller, more intimate neighborhoods. Songbirds, crickets, and butterflies are unafraid of the holy human residents. As an open elevator carries us up the side of a pillar-like skyscraper, the view is magnificent. Flower gardens are visible on rooftops and balconies. Perfect temperature control makes living at every level not only possible but pleasant. A gentle breeze brushes our cheeks as we rise up through the cathedral ceiling to level two, three, four, and on up to the very top, level twelve. What awaits us at the pinnacle of this glorious structure?

It will no longer be said to you, "Forsaken," nor to your land will it any longer be said, "Desolate"; but you will be called, "My delight is in her," and your land, "Married"; for the LORD delights in you, and to Him your land will be married.

ISAIAH 62:4

chapter seven
PICTURING PARADISE

THE CREATOR WHO MADE THE immeasurable universe, countless solar systems, and more stars than Abraham could count also made the immeasurable micro-world of the living cell. "A thimble full of cultured liquid can contain more than four billion single cell bacteria, each packed with circuits, assembly instructions, and miniature machines," some of which have rotary motors that spin at 100,000 rpm's.[1] Somewhere between these huge things and these tiny things is our normal visible experience. Amazingly, the One who created all of this actually chose to show Himself on several separate occasions to a handful of His prophets. And He chose to do this on a fairly normal visible scale. What's even more amazing, He looked like us. John said he saw a person seated on a throne (Revelation 4:2). God told John, "Write … what you see," (Revelation 1:11) and God tells us to read what he wrote (Revelation 1:3).

Our focus will be the book of Revelation, where the Lord paints for us some of the most tantalizing images of His throne in relation to Paradise and the New Jerusalem. Although we will concentrate primarily on what John actually saw on and around God's throne, we will compare these descriptions with other visions of God in the Bible. Many Biblical resources show diagrams of places like the Tabernacle in the wilderness, Solomon's Temple, and Ezekiel's Temple; however, one rarely finds a diagram of Paradise. Even though a great deal of information is given, assembling this final portion of the New Jerusalem puzzle poses unique challenges that are complex. We must be careful to note when comparative words are used such as *like* or *as*. Yet when these words are not used and when obvious figurative language is not employed, we can assume God means what He says. In other words, as in previous chapters, we will analyze and harmonize related passages using a literal approach. After all, we are literally treading on sacred ground here. Again, we are not looking for certainty but for biblically based possibilities. The ultimate goal, then, is to attempt to illustrate a possible picture of the Paradise of God.

CHALLENGES TO FACE

As we study the various descriptions of God's throne found throughout the Bible, the differences make a full picture elusive. However, the similarities between all of these scenes invite comparison. To begin with, we will be using the term "God's throne" to mean what John saw in Revelation 4:2.

Immediately I was in the Spirit; and behold, a throne was standing in heaven, and One sitting on the throne.
Revelation 4:2

Starting from this description, we will compare visions that Isaiah, Daniel, and Ezekiel saw that paint a similar portrait, providing links for our quest.

In the year of King Uzziah's death I saw the Lord sitting on a throne, lofty and exalted, with the train of His robe filling the temple. Isaiah 6:1

"I kept looking until thrones were set up, and the Ancient of Days took His seat...." Daniel 7:9

Now above the expanse that was over their heads there was something resembling a throne, like lapis lazuli in appearance; and on that which resembled a throne, high up, was a figure with the appearance of a man. ...As the appearance of the rainbow in the clouds on a rainy day, so was the appearance of the surrounding radiance. Such was the appearance of the likeness of the glory of the LORD.... Ezekiel 1:26, 28

Now, our goal is not to just attempt to visualize God's throne but to visualize it in relation to the New Jerusalem. This is complex for several reasons. Throughout the Bible and especially in the book of Revelation there are references to a temple in heaven. This temple contains furniture including an altar and the Ark of the Covenant. John even refers at one point to the throne's being located in the temple (Revelation 16:17). Yet John specifically says there is no temple in the New Jerusalem. He also says that nothing that defiles can enter the gates of the city (Revelation 21:27). The Bible repeatedly gives us amazing glimpses into what appears to be the inner chambers of God's courtroom (Job 1:6–7, I Kings 22:19–22, II Chronicles 18:21–22). From these passages, we see the stark reality that Satan and his angels have access to God's throne, at least until Satan is cast permanently from heaven.

And the great dragon was thrown down, the serpent of old who is called the devil and Satan, who deceives the whole world; he was thrown down to the earth, and his angels were thrown down with him. Then I heard a loud voice in heaven, saying, "Now the salvation, and the power, and the kingdom of our God and the authority of His Christ have come, for the accuser of our brethren has been thrown down, he who accuses them before our God day and night."
Revelation 12:9–10

We are also told that there will be a great battle in heaven between Michael and his angels and Satan and his demons just prior to Satan's being cast out (Revelation 12:7–8). We can draw some important conclusions from all of this. First, there must be

more to heaven than the Golden City. Not only that, but God's throne must move around. The fascinating mobility of God's throne is vividly described by Ezekiel.

> *Then the glory of the God of Israel went up from the cherub on which it had been, to the threshold of the temple.* Ezekiel 9:3a

> *Then the glory of the LORD departed from the threshold of the temple and stood over the cherubim. When the cherubim departed, they lifted their wings and rose up from the earth in my sight with the wheels beside them; and they stood still at the entrance of the east gate of the LORD's house, and the glory of the God of Israel hovered over them.* Ezekiel 10:18–19

> *Then the cherubim lifted up their wings with the wheels beside them, and the glory of the God of Israel hovered over them. The glory of the LORD went up from the midst of the city and stood over the mountain which is east of the city.* Ezekiel 11:22–23

> *And behold, the glory of the God of Israel was coming from the way of the east.... And the glory of the LORD came into the house by the way of the gate facing toward the east. ...And behold, the glory of the LORD filled the house.* Ezekiel 43:2, 4–5

He describes the Lord on His throne, coming, going, and even hovering, sometimes upon a unique chariot with wheels powered by four creatures. Isaiah and Daniel allude to it as well.

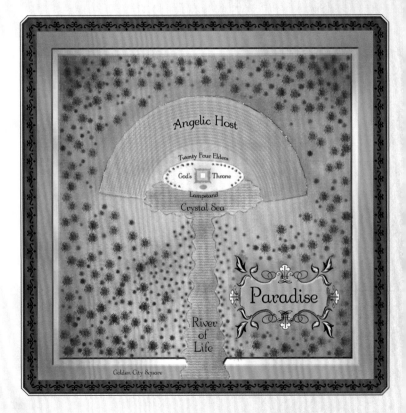

… Behold, the LORD is riding on a swift cloud….
Isaiah 19:1

"I kept looking until thrones were set up, and the Ancient of Days took His seat; His vesture was like white snow and the hair of His head like pure wool. His throne was ablaze with flames, its wheels were a burning fire." Daniel 7:9

Besides this mobility of God's throne, there are other challenges. For instance, we know that "God is spirit" (John 4:24) and God is omnipresent (Jeremiah 23:24). Yet the Bible makes it clear that, since the Incarnation, Jesus has a literal flesh and blood body that will last for all eternity. After His resurrection, He definitely moved from place to place, being sometimes visible, sometimes invisible.

We realize full well there is much we simply won't know until we get there. In this chapter, we have chosen to simply focus on how God chose to manifest Himself in relation to the New Jerusalem.[2] Specifically, we will see how the outdoor characteristics mentioned in the different visions of John might be a clue to connecting them together (Revelation 4, 5, and 22). Features such as a rainbow, lightning, and a sea (or lake), along with trees and a river, might be evidence that these visions can be harmonized. Thus, the beautiful word pictures that are given in Scripture will be our guide and inspiration as we prepare to paint a scene of what God's Paradise might possibly look like.

EXPLORING PARADISE

The Greek word translated *paradise* is used only three times in the Bible. It can mean a park or an orchard. The word comes from a Persian word that means "a walled park" or "enclosed garden."[3] From the verses that use this Greek word, we know the present location of Paradise, who is there, and what is there. We learn that Paradise is somewhere up above us. "I know a man in Christ who … was caught up to the third heaven … into Paradise" (II Corinthians 12:2–4). We also understand that Jesus is in Paradise. When Jesus was speaking to the thief on the cross He said, "Today you shall be with Me in Paradise" (Luke 23:43).

The third time the word *paradise* is used we find an important connecting clue. Paradise contains a certain type of tree called the Tree of Life. "To the one who conquers I will grant to eat of the tree of life, which is in the paradise of God" (Revelation 2:7 ESV). If we follow the clue of the Tree of Life, we find it is located within the gates of the city of the New Jerusalem.

Blessed are those who wash their robes, so that they may have the right to the tree of life, and may enter by the gates into the city. … And if anyone takes away from the words of the book of this prophecy, God will take away his part from the tree of life and from the holy city, which are written in this book. Revelation 22:14, 19

Since only certain people have access to the tree of life, we know it exists nowhere else. Thus we know that the Paradise of God is somewhere inside the gates of the city. As we continue to follow step by step the information given to us in the Bible, we will see that the tree of life is near the throne of God (Revelation 22:1–2). We will also see that the most likely location of Paradise with God's throne is at the top of the twelve levels of the New Jerusalem. We will see how the river of the water of life flows out from the centerpiece of the Golden City, God's throne, and down throughout the city. As we look carefully at what God has revealed, it is not too hard to imagine what it might be like to actually be there in Paradise.

HALLELUJAH SQUARE

We began our tour of the city in the previous chapter rising up through the twelve levels to the pinnacle. Now we step out at the top and see a walled park surrounded by a beautiful city square paved with gold.[4] The gold is so pure that it is "like transparent glass" (Revelation 21:21). Catching a glimpse through the gate, we can see many trees and even a river. This Paradise Park is God's open air throne room, the ultimate Central Park. Living at this height is no problem with our immortal bodies. Over our heads is the protective cloud canopy, and everything and everyone is bathed in the warm light emanating from the Lord.

Before we enter the park, imagine going to the edge of that city square where God somehow allows us a panoramic view. If from the very pinnacle of the New Jerusalem, eleven miles high, we let our eyes scan the horizon, we might be able to see through the haze for thousands of miles. But come now. Let's not just picture Paradise, let's explore Paradise. Since God has given us so many directional details that John recorded in the book of Revelation, we can actually draw a rough map of this garden. We must keep in mind that God did not give us the measurements of His garden, so this map is not to scale.

GOD'S OPEN AIR THRONE ROOM

The General Assembly

We know that right now the entire city of the New Jerusalem is home for "the general assembly and church of the firstborn who are enrolled in heaven" (Hebrews 12:23). However, we cannot be sure that a full gathering of everyone will occur in God's garden of Paradise.[5] Though we can't be sure, it does not seem likely that God's garden will be a gathering place for all believers. Our modern day solution for handling large crowds is to have huge screens with closed circuit TV cameras that make the one who is the center of attention at least visible to those far away. However, everyone knows we lose that sense of really being there. We find ourselves looking at the screen more than the speaker and

thinking that we might as well be home watching on TV. In this case, we would lose the intimacy of being in the Lord's visible presence. Of course, maybe God has solutions to this problem that we can't yet imagine. However, one of the most precious aspects of the character of God is that He desires to be close to us. Based on this thought, it seems more likely that the garden of Paradise is large but not necessarily big enough to include everyone. If so, then there might be various times when we have our turn to be there.

The Angelic Host

John also saw all around the throne of God tens of thousands of angels.[6]

> Then I looked, and I heard around the throne and the living creatures and the elders the voice of many angels, numbering myriads of myriads and thousands of thousands. Revelation 5:11 (ESV)

The angels could be either sitting or standing in something like a stadium or hovering in the air around the throne. Several other places in the Bible also describe a huge angelic host around the Lord.

> ... "The LORD came from Sinai ... and He came from the midst of ten thousand holy ones...." Deuteronomy 33:2

Micaiah said, "... I saw the LORD sitting on His throne, and all the host of heaven standing by Him on His right and on His left." I Kings 22:19

The Elders

The twenty-four elders are mentioned many times by John[7] and alluded to by Daniel (Daniel 7:10). John tells us where they sat and what they were wearing. He even tells us what kind of instruments they were holding and the songs they sang.

> Around the throne were twenty-four thrones; and upon the thrones I saw twenty-four elders sitting, clothed in white garments, and golden crowns on their heads. Revelation 4:4

> ... Each one [of the elders were] holding a harp and golden bowls full of incense, which are the prayers of the saints. And they sang a new song.... Revelation 5:8–9

The Lamps of Fire

In front of the throne, John saw seven lampstands, which were symbolic of seven churches in John's day.

> Then I turned to see the voice that was speaking with me. And having turned I saw seven golden lampstands; ... "the seven lampstands are the seven churches." Revelation 1:12, 20

He also saw "seven lamps of fire" which refers to each flame, visible symbols of "the seven Spirits of God."

> *Out from the throne come flashes of lightning and sounds and peals of thunder. And there were seven lamps of fire burning before the throne, which are the seven Spirits of God.* Revelation 4:5

The Crystal Sea

Now, looking in front of God's throne, we are given many exciting details. "And before the throne there was something like a sea of glass, like crystal" (Revelation 4:6). Since John uses the word *like*, we can't be sure, but it could be a laver, similar to the laver that was out in front of Solomon's Temple or the Tabernacle in the wilderness. However, it could be a large body of water, possibly a lake or pond. If it is actually a body of water, it could well be the source of the River of Life.

> *Then He said to me, "… I will give to the one who thirsts from the spring of the water of life without cost."* Revelation 21:6

> *"For the Lamb in the center of the throne … will guide them to springs of the water of life…."* Revelation 7:17

We can begin to visualize the beautiful setting. Light from the lamps of fire dance off the crystal-clear water as our eyes drink in the scene.[8]

The River of Life

Imagine having the privilege to stand before that throne and watch as healing waters issue forth from God. Daniel said "a fiery stream issued … forth from" the throne (Daniel 7:10 KJV). The water sparkles and shimmers with the light of God. We can hardly grasp the magnitude. What is before our eyes affects the entire world. These waters flow through the garden of Paradise, continue out from the garden, divide into streams throughout the New Jerusalem, run outside the gates toward the temple, branch out onto the Holy Allotment, spill over the sides of the plateau in magnificent waterfalls, and finally travel both eastward and westward throughout the Promised Land, healing not only the Dead Sea but the waters of the earth. What a picture of God's throne as the ultimate source of blessing!

In the Shade of the Tree of Life

Rows of stately trees on both sides of the crystal-clear River of Life form a focal point directing our eye toward God's throne. To the right and to the left we see the famous Tree of Life, once forbidden but now within reach.

Then he showed me a river of the water of life, clear as crystal, coming from the throne of God and of the Lamb, in the middle of its street. On either side of the river was the tree of life, bearing twelve kinds of fruit, yielding its fruit every month.... Revelation 22:1–2

The garden is actually an orchard because the trees are laden with fruit. Since we are told that the trees bear twelve kinds of fruit, it could possibly mean that the term "tree of life" is a tree species that includes twelve different varieties. We can compare these trees to the trees in the Holy Allotment, which are also described as bordering a river.

Now when I had returned, behold, on the bank of the river there were very many trees on the one side and on the other. ... "By the river on its bank, on one side and on the other, will grow all kinds of trees for food. Their leaves will not wither and their fruit will not fail. They will bear every month because their water flows from the sanctuary, and their fruit will be for food and their leaves for healing."
Ezekiel 47:7, 12

Since Ezekiel says that the leaves of these trees "will not wither," they are evergreen, possibly like citrus trees or even palm trees. Thus, although we can't be certain, it is likely that the Tree of Life also has leaves that are evergreen. We are told spe-cifically that representations of palm trees decorated Solomon's Temple and will decorate Ezekiel's Temple (interestingly, along with Cherubim, the protectors of the Tree of Life [Genesis 3:24; I Kings 6:29, 32, 35; II Chronicles 3:5; Ezekiel 40:16, 22, 26, 31, 34, 37; 41:18–20, 25–26]).

From the ground to above the entrance cherubim and palm trees were carved, as well as on the wall of the nave. Ezekiel 41:20

Thus, it is likely that the Tree of Life near God's throne is most like a palm tree.

The Cherubim

Now with the help of dramatic descriptions from the Bible, let us continue to imagine what it would be like to actually approach the eternal throne. Encircling and undergirding the throne are four unique living creatures.

Ezekiel saw these creatures on two separate occasions and took the time to record amazing details about them.

As I looked, behold, a storm wind was coming from the north, a great cloud with fire flashing forth continually and a bright light around it, and in its mist something like glowing metal in the midst of the fire. Within it there were figures resembling four living beings. And this was their appearance: they had human form. Each of them had four faces and four wings. Their legs were straight and their feet

were like a calf's hoof, and they gleamed like burnished bronze. Under their wings on their four sides were human hands. As for the faces and wings of the four of them, their wings touched one another; their faces did not turn when they moved, each went straight forward. As for the form of their faces, each had the face of a man; all four had the face of a lion on the right and the face of a bull on the left, and all four had the face of an eagle. Such were their faces. Their wings were spread out above; each had two touching another being, and two covering their bodies. And each went straight forward; wherever the spirit was about to go, they would go, without turning as they went. In the midst of the living beings there was something that looked like burning coals of fire, like torches darting back and forth among the living beings. The fire was bright, and lightning was flashing from the fire. And the living beings ran to and fro like bolts of lightning. Ezekiel 1:4–14

Ezekiel said the living beings were called "cherubim" (Ezekiel 10:20). Several hundred years later, John saw them and added his description.[9]

…There was … in the center and around the throne, four living creatures full of eyes in front and behind. The first creature was like a lion, and the second creature like a calf, and the third creature had a face like that of a man, and the fourth creature was like a flying eagle. And the four living creatures, each one of them having six wings, are full of eyes around and within; and day and night they do not cease to say, "Holy, Holy, Holy is the LORD God, the Almighty, who was and who is and who is to come." Revelation 4:6–8

They seem human yet have animal features. They seem animal-like, yet they speak and even sing! Besides praising God's holiness, they do and say other things (Revelation 5:8, 14; 15:7). Trying to picture what they might have looked like is a real challenge but not totally impossible. Their multiple wings could be like butterfly or insect wings or even like the delicate, feathery wings of the Bird of Paradise. However, because of the size of the creatures, we usually assume the wings were more like that of a large bird. The overall form of the legs was straight like a human's, yet "their feet were like a calf's hoof, and they gleamed like burnished bronze" (Ezekiel 1:7).

Actually, cherubim are mentioned throughout the Bible and are a fascinating subject. Although

it is possible that there are different types of cherubim, if we combine all the information that is revealed, we obtain a fuller picture.[10] These creatures were used of God to guard the entrance to the Garden of Eden after Adam and Eve sinned. Two huge replicas of cherubim were placed in the temple's inner chamber, the Holy of Holies, by Solomon.

> *Also in the inner sanctuary he made two cherubim of olive wood, each ten cubits high. Five cubits was the one wing of the cherub and five cubits the other wing of the cherub; from the end of one wing to the end of the other wing were ten cubits. … He also overlaid the cherubim with gold.*
> I Kings 6:23–24, 28

Two cherubim were already on the Ark of the Covenant. Thus the Holy of Holies had a total of four cherubim, completing and complementing the configuration that John and Ezekiel saw.[11]

Their Wheels

We have only just begun to learn about these astonishing creatures. When Ezekiel saw his vision he described wheels next to each cherub.

> *Now as I looked at the living beings, behold, there was one wheel on the earth beside the living beings, for each of the four of them. The appearance of the wheels and their workmanship was like sparkling beryl, and all four of them had the same form, their appearance and workmanship being as if one wheel were within another. Whenever they moved, they moved in any of their four directions without turning as they moved. As for their rims they were lofty and awesome, and the rims of all four of them were full of eyes round about. Whenever the living beings moved, the wheels moved with them. And whenever the living beings rose from the earth, the wheels rose also. Wherever the spirit was about to go, they would go in that direction. And the wheels rose close beside them; for the spirit of the living beings was in the wheels. Whenever those went, these went; and whenever those stood still, these stood still. And whenever those rose from the earth, the wheels rose close beside them; for the spirit of the living beings was in the wheels.* Ezekiel 1:15–21

Since we are told that "the spirit of the living beings was in the wheels," rather than the wheels being mechanical, the wheels

somehow seem to be one with the creatures. Thus, it could be similar to the rotary motors inside the micro-machines of a living cell, only on a larger scale. More detail about the wheels is given when Ezekiel sees the cherubim a second time.

> *Then I looked, and behold, four wheels beside the cherubim, one wheel beside each cherub; and the appearance of the wheels was like the gleam of a Tarshish stone. As for their appearance, all four of them had the same likeness, as if one wheel were within another wheel. When they moved, they went in any of their four directions without turning as they went; but they followed in the direction which they faced, without turning as they went. Their whole body, their backs, their hands, their wings and the wheels were full of eyes all around, the wheels belonging to all four of them. The wheels were called in my hearing, the whirling wheels. Ezekiel 10:9–13*

Since the wheel in a wheel configuration does not turn in the direction that it goes, it could visually be similar to a gyroscope. We also find clues about the wheels in other parts of Scripture. The configuration of wheels and cherubim is sometimes even called a chariot. King David referred to this when he was given plans for the temple from God, which he then passed on to his son Solomon.

Let the one who is thirsty come

Revelation 22:17

... And gold for the model of the chariot, even the cherubim that spread out their wings and covered the ark of the covenant of the LORD. [The ESV says, ... also his plan for the golden chariot of the cherubim....] I Chronicles 28:18

Since the readers of the first century A.D. were probably familiar with this information from the Old Testament, John would not have to repeat the detail about the wheels.

Full of Eyes

These mysterious creatures are certainly not easy to picture. To complicate things further, both John and Ezekiel tell us repeatedly that these beings were "full of eyes."

Their whole body, their backs, their hands, their wings and the wheels were full of eyes all around, the wheels belonging to all four of them.
Ezekiel 10:12

And the four living creatures ... are full of eyes around and within.... Revelation 4:8

Most likely the phrase "full of eyes" holds a meaning that is not easily translated.[12] Ezekiel could have been saying that there were so many unusual things about these creatures that it made his eyes jump from one thing to another. In other words, they were an eyeful!

Their Faces

One final characteristic of the cherubim has been extremely difficult to picture. The living beings are described as having four faces.[13] Both John and Ezekiel could have meant that the four surfaces or visible sides of the head each had a different look. In other words, the head of the cherub most likely looked like that of a human from the front, had the profile of a lion when viewed from the right, had the profile of an ox or "calf" when viewed from the left, and looked like the back of an eagle's head when viewed from the rear. The words "like a flying eagle" (Revelation 4:7) could mean that the feathers were sticking out in back as if in flight.

Their Hands

Under their wings were at least two hands.[14] The cherubim did things with these hands in front of both Ezekiel and John (Ezekiel 10:6–8; Revelation 15:7). If we had been standing there and seen these animal-like creatures talking, their four faces, their wheels, the fire, the lightning, their hoof-like feet, and their human-like hands reaching out from under their wings, we would have, along with Ezekiel, been awestruck.

THE ETERNAL THRONE OF GOD

Four different prophets had the incredible privilege of actually seeing a vision of the God of the universe. And now as we have the privilege to look through all of their eyes, His presence becomes wonderfully imaginable and real. Above the four cherubim

was a diamond-like platform.[15] On top of that glimmering surface was a throne. And of all things, somewhere over the throne was a rainbow. "There was a rainbow around the throne, like an emerald in appearance" (Revelation 4:3). Although John mentions only the color of an emerald, Ezekiel describes this radiance as having the full spectrum of colors as in a normal rainbow.

As the appearance of the rainbow in the clouds on a rainy day, so was the appearance of the surrounding radiance. Such was the appearance of the likeness of the glory of the LORD.... Ezekiel 1:28

And on that throne ...

... high up, was a figure with the appearance of a man. Then I noticed from the appearance of His loins and upward something like glowing metal that looked like fire all around within it, and from the appearance of His loins and downward I saw something like fire; and there was a radiance around Him. Ezekiel 1:26–27

... He who was sitting was like a jasper stone and a sardius in appearance.... Revelation 4:3

The presence of fire in and around the throne is described by Ezekiel, Daniel, and John.

As I looked, behold, a storm wind was coming from the north, a great cloud with fire flashing forth continually and a bright light around it, and in its midst something like glowing metal in the midst of the fire. Ezekiel 1:4

"... His throne was fiery flames; its wheels were burning fire." Daniel 7:9 (ESV)

From the throne came flashes of lightning, and rumblings and peals of thunder.... Revelation 4:5

John says that "His face was like the sun shining in its strength" (Revelation 1:16). All this fire might cause some to picture Oz, the Terrible from the classic movie *The Wizard of Oz*. The wizard cruelly caused poor Dorothy and her companions great fear by portraying himself as a huge angry face amidst roaring flames. But biblical visions of God are different. In spite of all the fire, details of a whole person were still visible. And that Person, though all-powerful, is also Love incarnate. Though John faints at the sight, the Lord reaches out and touches him, saying, "Do not be afraid."

... I saw one like a son of man, clothed in a robe reaching to the feet, and girded across His chest with a golden sash. His head and His hair were white like white wool, like snow; and His eyes were like a flame of fire. His feet were like burnished bronze, when it has been made to glow in a furnace.... In His right hand

He held seven stars, and out of His mouth came a sharp two-edged sword; and His face was like the sun shining in its strength. When I saw him, I fell at His feet like a dead man. And He placed His right hand on me, saying, "Do not be afraid; I am the first and the last, and the living One; and I was dead, and behold, I am alive for-evermore, and I have the keys of death and of Hades."
Revelation 1:13–18

THERE'S NO PLACE LIKE HOME

When we get in this close, looking at all that is near the very throne of God when it is in Paradise and when it is in the temple, we find all the makings of home! He has a chair (His throne), a table (the Table of Bread), and lamps. No phone or Internet access is visible, yet there is a sweet scent of precious incense in the air. He tells us it's our prayers.[16] We find no bed, but then He doesn't sleep. We see a place to cook (the Golden Altar) and a place to wash (the Crystal Sea). Not only that, but He has pets (the cherubim) and a vehicle (His chariot throne). As our eyes scan the surroundings, we see a gorgeous garden with a river and trees. He has servants (angels) and He wants His family (us!) around Him all the time. He likes music (singing, trumpets, and harps). He loves His work (to govern), and He gives some the privilege of helping with that (the elders). It is a safe, protected place, full of harmony, beauty, peace, joy, laughter,

and fellowship. At one time, He gave some a little sample taste of Paradise in earthly Jerusalem.

Everyone kept feeling a sense of awe ... and had all things in common.... [And they were] continuing with one mind ... together with gladness and sincerity of heart, praising God.... Acts 2:43–47

They shall come and shout for joy
on the height of Zion...
and their life shall be like
a watered garden,
and they shall never languish again.

JEREMIAH 31:12

In Conclusion

CALLING BEREAN IMAGINEERS

OVERALL, THIS QUEST TO UNDERSTAND the visual aspects of the New Jerusalem, Paradise, and God's throne is just a start. Like mining for silver (Proverbs 2:2–4), some veins have proven to be especially rich—rich with pictorial possibilities. Hopefully, other veins will lure the reader and even the artist to further exploration. During Bible times, some of God's prophets were told to make visual aids to clarify and illustrate what God had to say (Ezekiel 4:1–3; 37:15–20). They were simply crafted from found objects. Down through the centuries, believers have followed this example, using a variety of types of visuals to help them communicate God's Word. Sometimes they simply used whatever was available, and sometimes they were able to take advantage of the latest techniques of their day. For instance, when oil paint was discovered, artists were greatly enabled to gain a new level of realism. Because the paint was slow to dry, they had plenty of time to add or take away, making corrections. In particular, Bible stories came to life like never before. More recently, with the discovery of motion pictures, we have obtained incredible opportunities for even more realism in portraying the Bible's historical narratives (i.e., *The Passion of the Christ, The Nativity Story*).

Today, however, with the invention of computer generated realism, we have an opportunity never before available. It is now possible to demonstrate in a very realistic manner the spectacular visions of God that are described in the Bible. Movement and special effects can be realistically animated, like the cherubim with four faces that move without turning; the appearance of burning coals and lightning between the cherubim; the whirling wheels inside wheels; fire in, on, and around the throne; fire enfolding itself; fire on top of a crystal sea; and even God's throne moving from place to place. Hopefully, artists will be challenged to use both new technology and whatever abilities they have to illustrate what the Bible actually says about heaven. Disney's artistic team were called the Imagineers. But in this case, what we need are Berean Imagineers. The Bereans were commended in the Bible for personally and carefully examining the Scriptures. (Acts 17:11) We need artists who are willing to stay within the box of the authority of the Scriptures yet take full advantage of the room God gives us for artistic license. Quality visuals may stir people to become more informed about what God has revealed about Himself and the future He has promised.

WHAT LOVE IS THIS?

To sum up all that has been discussed, God has certainly told us what on earth heaven is like. He seems to have shown Ezekiel prophecies that would pertain to the nation of Israel while He showed John the prophecies that would pertain to believers as a whole. Although we might not have all the puzzle pieces, harmonizing the two gives us a pretty full picture. If this proposed interpretation is correct, heaven on earth is more normal than most of us expected.

At the beginning of this quest, several goals were put forth. Gaining knowledge about the many characteristics of the New Jerusalem is merely a stepping stone. Learning about God's home is just one way to keep our focus on who God is. First of all, in the following verse, God communicates His understanding of our need for security and stability.

> *… Your eyes will see Jerusalem, an undisturbed habitation,*
> *a tent which will not be folded; its stakes will never be*
> *pulled up.… Isaiah 33:20*

Again and again throughout the Bible He demonstrates His tenderness, touching on countless emotional, physical, and spiritual needs as He reveals details about our future.

Secondly, God has shown us His mercy in what He plans to do with the nation of Israel. The Vinedresser is pruning and has not given up on the vine He planted. Of Israel, He says,

> *"I will rejoice over them to do them good and will faithfully*
> *plant them in this land with all My heart and with all*
> *My soul." Jeremiah 32:41*

> *"Calling … the man of My purpose [Abraham] from a far*
> *country. … I have planned it, surely I will do it. … I will*
> *grant salvation in Zion, and My glory for Israel."*
> *Isaiah 46:11, 13*

And Gentiles "from every nation and all tribes and peoples and tongues" (Revelation 7:9) who believe in God's Messiah have been grafted in! It's not either, or, but all of His elect that will enjoy the promises fulfilled.

Thirdly, God's promises of future blessing display His proactive love for us. It is an understatement to say that He has gone out of His way to prepare us for the future. Inevitable trials and heartaches lie ahead for each one of us, and possibly even persecution. He has tried to prepare us by giving us an incredible amount of detail of what lies beyond those trials, providing a clear picture of the long view.

Finally, the scripture references in this study manifest God's gracious kindness. Can anyone truly grasp the eternal Creator condescending to live among His rebellious creatures, not just for 33 years, but permanently?

These four, His tenderness, His mercy, His love, and His kindness, all help define a single word that is used over 250 times

in the Old Testament. Sometimes translated as *tender mercies* or *lovingkindness,* the word is *khesed.* The Hebrew word actually carries with it an even deeper meaning. It is a loyal love or unconditional love. God's unconditional love for Israel is a picture of His *khesed* love for each of us who have put our faith in the Lord Jesus Christ. And His home's being set down here on this planet illustrates this love.

Hopefully, our future existence with the Lord is no longer a vague, foggy idea for us, a dim and distant hope. Examining the many physical details about God's future world capital gives us much that we can relate to. In fact, what we see in the present might trigger thoughts about our future. One example in everyday life that might remind us specifically of the Golden City is simply a shopping mall, such as Water Tower Place in Chicago, Illinois. With its seven floors of stores and restaurants, it is definitely a luxurious place that puts shoppers in a good mood. Most likely without realizing it, the interior designers and planners have in a small way duplicated many characteristic details of the New Jerusalem. Note in the following description details that are similar:

1. The River of Life that would create waterfalls on the various levels as it moves down to sea level
2. The Tree of Life, lush vegetation, and flowers
3. Jasper walls that are clear like glass
4. A city made of gold
5. The vast array of many colored jewels
6. The perfect light of the Lord
7. Beautiful music

Escalators gently carry people both up and down past a two-story cascading waterfall that is bordered by live greenery. At seven different levels, shops display their multi-colored treasures behind clean glass walls. Brass is everywhere reflecting a golden hue with the support of perfectly placed lighting. Lush greenery and well-tended flowers are abundant. Pleasant music complements the scene.

Another example is the massive yet beautiful Opryland Hotel in Nashville, Tennessee. Six stories of hotel rooms are wrapped around multiple sections of a carefully tended garden paradise, full of thousands of exotic varieties of plants. All of this is covered by a glass canopy that protects the gardens from the sun and the rain.

As a final example, imagine sitting in a theatre before a play begins. The house lights are turned all the way down, leaving us engulfed in blackness, wondering in suspense.

> *... The sun became black as sackcloth made of hair, and the whole moon became like blood; and the stars of the sky fell to the earth....* Revelation 6:12–13

Suddenly a thin streak of light pierces the darkness. The huge stage curtain is majestically drawn apart.

The sky was split apart like a scroll when it is rolled up....
Revelation 6:14

*"For just as the lightning comes from the east and flashes
even to the west, so will the coming of the Son of Man be."*
Matthew 24:27

Music fills our ears as a brilliantly lit stage is revealed. God's show
of all shows will be one grand climax. When we look up and see
the ultimate Hero and His armies and His home descending, re-
alizing He has come to rescue us, His bride, we will …

*… have songs as in the night when you keep the festival,
and gladness of heart as when one marches to the sound of
the flute, to go to the mountain of the LORD, to the Rock
of Israel.* Isaiah 30:29

We will say,

*… "Behold, this is our God for whom we have waited that He
might save us. This is the LORD for whom we have waited;
let us rejoice and be glad in His salvation."* Isaiah 25:9

And He will say to us,

*Come, my people, enter into your rooms and close your
doors behind you; hide for a little while until indignation*

*runs its course. For behold, the LORD is about to come
out from His place to punish the inhabitants of the earth
for their iniquity.* Isaiah 26:20–21a

And as our Hero begins to vanquish evil, the musicians really
let loose.

*… When He strikes with the rod. And every blow of the
rod of punishment, which the LORD will lay on him, will
be with the music of tambourines and lyres; and in battles,
brandishing weapons, He will fight them.* Isaiah 30:31–32

May we sense with a greater awe His omnipotence. He has pre-
dicted with confident clarity how He will finish what He started.
Time is going somewhere! His purpose cannot be altered.

May Thy kingdom come,
Thy will be done!

I have loved you with an everlasting love;
therefore I have drawn you with loving-
kindness (khesed).

JEREMIAH 31:3

AN INVITATION

DEAR READER,

My own life and eternity have been affected by someone sharing the following information with me. I want to be sure to share that same information with you, in case it is something you have never heard before. Although it starts with bad news, it finishes with good news.

THE BAD NEWS:

… All have sinned and fall short of the glory of God. Romans 3:23

"… The soul who sins will die." Ezekiel 18:4

… Without shedding of blood is no remission. Hebrews 9:22 (KJV)

THE GOOD NEWS:

… "'As I live!' declares the Lord GOD, 'I take no pleasure in the death of the wicked, but rather that the wicked turn from his way and live….'" Ezekiel 33:11

More good news. The only One who was innocent took your punishment:

… They pierced My hands and My feet. Psalm 22:16

But He was pierced through for our transgressions, He was crushed for our iniquities; the chastening for our well-being fell upon Him, and by His scourging we are healed. Isaiah 53:5

… The gift of God is eternal life through Jesus Christ our Lord. Romans 6:23 (KJV)

He died that you might live. If you believe this, you can pray and ask Jesus to save you from your sins.

For there is no distinction between Jew and Greek; for the same Lord is Lord of all, abounding in riches for all who call on Him; for "whoever will call on the name of the Lord will be saved." Romans 10:12–13

This invitation is open to "every nation and all tribes and peoples and tongues" (Revelation 7:9).

> *"… Whoever calls on the name of the LORD will be delivered."* Joel 2:32a

If you want Christ's sacrifice to apply to your account, you can talk to God and tell Him:

Dear God,
I have sinned against You. Please forgive my sins and allow Jesus' sac-rifice to count as payment for my sin. Thank You for Your great provision. Thank You for saving me.

If you believe this and have prayed this prayer, then you will inherit God's Kingdom promises.

> *And if you belong to Christ, then you are Abraham's descendants, heirs according to promise.* Galatians 3:29

ENDNOTES

INTRODUCTION
1. For a book on the general topic of heaven, see: Randy Alcorn, *Heaven* (Carol Stream: Tyndale House Publishers, Inc., 2004).
2. Randall Price, *Jerusalem in Prophecy* (Eugene, OR: Harvest House Publishers, 1998), 304.

LOCATION, LOCATION, LOCATION
1. Randall Price, *The Temple and Bible Prophecy* (Eugene, OR: Harvest House Publishers, 2005), 467, 531–32.
2. Ibid., pp. 234–35, 512, 637.
3. There are a number of different opinions concerning this proposed interpretation, particularly in the area of timing. Though we repeat, "Even the best of prophecy scholars and experts disagree on how to interpret the biblical doctrine of the New Jerusalem" (Price, *Jerusalem in Prophecy,* 304). We will carefully examine all the information that God gives us and attempt to answer these objections.

MAJESTIC MEASUREMENTS
1. *Ryrie Study Bible* (Chicago: Moody Publishers, 1995), note on Revelation 21:16–17.
2. Fitzpatrick, Richard, *Euclid's Elements*, http://www.farside.ph.utexas.edu/euclid.html (2006 edition), Preface.
3. http://www.bookrags.com/biography/hero-of-alexandria-wom/, 2010.
4. Various translations of the book of Ezekiel can lead to confusion because neither of the terms *rod* or *cubit* is used in numerous passages where numbers are given. In Ezekiel 45:1, for instance, some translations assume cubits and don't put it in italics. (The KJV and the NASB do use italics). Alexander, Willmington, Sulley, and others feel the term *rod* is implied. Alexander says this in his discussion of Ezekiel 45:1–8:
 The specific allotment is described as an offering to Yaweh, "an holy portion of the land" (v. 1) ... This land segment will measure 25,000

by 10,000. Though the text does not explicitly state that "rods" are the nature of the measurement, this certainly seems to be the case when one examines verse 2. The Temple precinct, which lies in the middle of this allotment, is measured 500 by 500 square. In contrast, the border around it is explicitly stated to be fifty cubits. The term "cubit" appears to be used purposefully to contrast the fifty measurements from the 500. Likewise, the same dimensions of the Temple complex are revealed in 42:15–20 as 500 "rods." Ralph H. Alexander, *Ezekiel* (Chicago: Moody Press, 1995), 153.

Ezekiel 40:5 gives us the biblical definition of a rod. The size of a rod is estimated by Alexander and Willmington to be 10.5 feet, and Sulley 12 feet. According to Henry Sulley, the Holy Allotment would be 57 miles in each direction. The city Ezekiel saw would be approximately 11 miles on each side. Henry Sulley, *Commentary on Ezekiel,* (1887), 85 (for website see Bibliography). Also, Kober has an interesting diagram of the Holy Allotment: http://www.middletownbiblechurch.org/proph/river.htm.

5. Randall Price, *The Temple and Bible Prophecy* (Eugene, OR: Harvest House Publishers, 2005), 467.
6. Wise, Michael, Martin Abegg Jr., and Edward Cook. *The Dead Sea Scrolls: A New Translation*. New York: HarperOne, 2005, 557–61.
7. Michael Wise, Martin Abegg Jr., and Edward Cook, *The Dead Sea Scrolls: A New Translation* (New York: HarperOne, 2005), 557–63.
8. Steve Austin, *Messiah's Earthquake: Topographic Change and Tectonics in End-Time Prophecy*, audiotape of lecture (Institute for Creation Research, 2007).

GOD'S HOLY MOUNTAIN

1. The following authors agree: Alva J. McClain, *The Greatness of the Kingdom* (Winona Lake: BMH Books, 1974), 512; John F. Walvoord, *Prophecy* (Nashville, Thomas Nelson Publishers, 1993), p. 172.
2. The word *degrees* is translated *steps* in Ezekiel 40:6, 22, 26 and Exodus 20:26.
3. Source: *A Hebrew and English Lexicon of the Old Testament*, Brown, Driver, and Briggs, Oxford University Press, NY, 1951, AB. Loc.
4. For a discussion with diagrams about heaven on earth, see Randall Price, *The Temple and Bible Prophecy* (Eugene, OR: Harvest House Publishers, 2005), 193–95.
5. Walt Brown, *In the Beginning* (Phoenix: Center for Scientific Creation, 2008), 365–66.
6. This was a common assumption at Qumran. According to 2 Baruch 4, the heavenly Jerusalem originally stood in Paradise; but after Adam sinned, it was taken to and preserved in heaven. It was shown to Abraham in a vision and to Moses on Mount

Sinai. According to 2 Esdras 10:44–59, Ezra also had a vision of the heavenly city." J. Julius Scott Jr., *Jewish Backgrounds of the New Testament* (Grand Rapids: Baker Academic, 1995), 291(footnote 37).

7. Apparently some people that lived in the Patriarchal age had knowledge of certain truths, although we are not told how they knew those truths. For example, Cain and Abel knew to bring sacrifices (Genesis 4:3–4); Enoch knew the Lord would come with 10,000 of His saints in a time of judgment (Jude 14–15); Noah knew the difference between clean and unclean animals (Genesis 7:2); the citizens of Babel knew heaven was up (Genesis 11:4); Job knew he would someday have a bodily resurrection and knew his Redeemer would someday stand on the earth (Job 19:25–26); and Abraham knew about God's future city (Hebrews 11:8–10).

8 *The Zondervan Pictorial Encyclopedia of the Bible*, vol. 5 (Grand Rapids: Zondervan, 1980), 666.

9. David Roberts, "Age of Pyramids", *National Geographic* (January 1995), 15.

10. Lorna Oakes and Lucia Gahlin, *Ancient Egypt* (London: Hermes House 2002), 46.

11. Ibid., 52.

12. "Age of Pyramids", *National Geographic* (January 1995), 7.

13. *Ancient Egypt*, 100.

14. James Putnam, *Eyewitness Pyramid* (New York: DK Publishing, 2004), 18, 20.

THE ORDER OF EVENTS

1. The word *standard* can mean a *physical object intended to alert people*. *A Hebrew and English Lexicon of the Old Testament*, author: William Gesenius, translator: Edward Robinson, editor: Francis Brown, contributors: S. R. Driver, C. A. Briggs, Oxford University Press, NY, 1951. (location of page: AB. Loc)

2. Looking at the full context of Isaiah 26:5 and 6, we see a previous passage (Isaiah 25:10–12) talking of Moab's pride and its city being laid low. Then Isaiah 26:1–6 is given as a contrast. Verse 1 and 2 speak of a *strong city* where God has set up *salvation* walls and ramparts. Only the *righteous nation* can enter. Verse 5 and 6 continue that contrast to 25:10–12 and describe God's city. The Hebrew word translated *lofty* is also translated as *safe, exalted, and excellent,* referring to the Lord or His name (Proverbs 18:10; Isaiah 33:5; Psalm 148:13). The afflicted and the helpless, those who have waited eagerly for the Lord (v. 8), are now freely walking about on smooth ground (v. 7). The Hebrew word for *trample* does not necessarily mean anger is involved because it is also used to describe a potter walking in his clay (Isaiah 41:25). It could be conveying the irony that those who were formerly *poor*

(the Hebrew word can mean *humble*) are now walking on streets of gold.

3. *The Temple and Bible Prophecy*, 126.

4. *Jerusalem in Prophecy*, 309.

5. For a discussion of the permanence of the earth, see:

Marvin J. Rosenthal, "A New Heaven, a New Earth, a New Jerusalem, We Didn't Even Know How to Dream!" *Zion's Fire* May/June, 1993. Briefly, some of his reasons are:

1) The word *restitution* (or *regeneration*) "means *new birth* and is used by the apostle Paul to describe the believer's *new birth* (Titus 3:5). Thayer, in his *Greek Lexicon of the New Testament,* has written concerning the *regeneration:* 'It is that signal and glorious change of all things [in heaven and earth] for the better, that restoration of the primal and perfect condition of things which existed before the fall of our first parents....'"

2) In the phrase *new heavens and new earth,* the Greek word for "new" means *new* in quality, not *new* in time. It is the Greek word *kainos* and is also used in "Therefore if anyone is in Christ, he is a new creature" (II Corinthians 5:17). In this context a brand new person is not created but rather renovated.

3) The phrase *passed away* (Revelation 21:1) comes from the root word *parerchomai* which means *great change* but never *annihilation* or *passing out of existence.*

4) Some have argued that II Peter 3:6 refers to the annihilation of our planet. However, the passage makes the comparison of end time (Day of the Lord) destruction to the Noahic Flood. The world *perished*, but not the planet.

5) Both Peter and Paul speak of "the day of the Lord" (I Thessalonians 5:2), saying that Christ's coming will come "like a thief in the night." "Jesus cannot come *as a thief in the night* at the end of the Millennium. The Millennium is His earthly Kingdom. He will already be physically present."

6) Speaking of the New Jerusalem's landing, Hebrews 12:26, quoting Haggai 2:6, says that the Lord will shake the earth "once more," not twice.

6. Psalms use poetic language and we must be careful when interpreting them. However, Jesus said that "all things which are written about Me in ... the Psalms must be fulfilled" (Luke 24:44).

DELIGHTING IN THE DETAILS

1. A good discussion of this can be found in the following: Alva McClain, *The Greatness of the Kingdom* (Winona Lake: BMH Books, 1959), 249–51.

2. The gate names translated into English might have the following meanings: Reuben—*look a son*, Judah—*praise*, Levi—*attachment*, Joseph—*may the Lord add* or *He has taken away*, Benjamin—*son of honor or good fortune*, Dan—*justice*, Simeon—*hearing*, Issachar—*reward*, Zebulun—*dwelling*, Gad—*luck or fortune*, Asher—*happy*, Naphtali—*wrestling*. Translations are from the *Ryrie Study Bible:* p. 51–52, 61.

3. Astronauts have a thin coat of gold on their visors to protect from the ultraviolet rays, yet they can see through it. This might explain how the gold could be "like clear glass."

4. Interestingly, stained glass windows in churches mimic the effect of light shining through jewels.

PICTURING PARADISE

1. *Unlocking the Mystery of Life,* DVD. Executive Producer: James W. Adams, Producer/Director: Lad Allen. (Illustra Media: La Mirada, CA, 2002).

2. Genesis 1:27 says, "God created man in His own image, in the image of God He created him," and he made Adam in the likeness of God. The Bible uses the same phrase when connecting Adam and his son Seth; Adam "became the father of a son in his own likeness, according to his image" (Genesis 5:3). Although God is spirit, He frequently chose to manifest Himself in the form of a human even before the Incarnation. In this sense, though some might say we are making God look like us, He made us look like Himself.

3. *Heaven*, 55.

4. The word translated street does not just mean an ordinary street but designates it as a city square.

5. We know that someday a great multitude will stand before the throne. However, we cannot be certain where God's throne is at the time of this gathering (Revelation 7:15).

 After these things I looked, and behold, a great multitude which no one could count, from every nation and all tribes and peoples and tongues, standing before the throne and before the Lamb, clothed in white robes, and palm branches were in their hands. Revelation 7:9

 John actually had the opportunity to be brought into the future to see that throng "from every nation and all tribes and peoples

and tongues" (Revelation 7:9); "these [were] the ones who [came] out of the great tribulation" (Revelation 7:14). Surely as John saw the multi-cultural mass of humanity standing there he began to grasp how "God so loved the world" (John 3:16).

6. At one point John also saw seven angels in front of the throne (Revelation 8:2).

7. Revelation 4:4, 10; 5:5–8, 11, 14; 7:11, 13; 14:3; 19:4.

8. Since the crystal sea is in front of the throne as well as these lamps, it is very possible that the fire would be reflected in the water. This would be consistent with Daniel's description of the "fiery stream" (Daniel 7:10 KJV). Revelation 15:2 mentions a sea also and says that it looked like it was water mixed with fire.

 And I saw what appeared to be a sea of glass mingled with fire—and also those who had conquered the beast and its image and the number of its name, standing beside the sea of glass with harps of God in their hands. Revelation 15:2 (ESV)

 Again, this could indicate that the lamps were very near the water. This effect would most likely occur only if the sea itself were not very large. An additional clue might be in the specific directions given to Moses concerning the Tabernacle in Exodus 25:37: "Then you shall make its lamps seven in number; and they shall mount its lamps so as to shed light on the space in front of it." God told him that the light should be directed. In other words, it would be dramatic directional lighting.

9. Since John's descriptions of God's throne in Revelation 4, 5, and 22 all have outdoor characteristics, the possibility exists that they can be harmonized. In other words, just because John didn't mention the creatures in chapter 22 doesn't mean they weren't there. Likewise, just because he didn't mention the river and trees in chapters 4 and 5 doesn't mean they weren't there as well. It is even possible that John didn't describe any wheels beneath the cherubim, since he knew Ezekiel had already given that information. Maybe John's description of the living creatures is meant to be enough for us to make the connection.

10. Isaiah also saw a vision of creatures like this and he called them seraphim (Isaiah 6:2). The word *seraphim* simply means *burning*. This would correlate with the fire Ezekiel saw in his vision of cherubim. Isaiah's creatures had six wings, like the creatures that John saw. One difference was that Ezekiel saw only four wings on each creature instead of six. Since the other details are the same, it is possible that when Ezekiel says that two wings covered their bodies, two additional wings were wrapped around the bodies of the cherubim and were not readily discernible. Some of the references to cherubim are Genesis 3:24; Exodus 25:18–22, 26:1; Numbers 7:89; I Samuel 4:4; II Samuel 22:11.

11. The exact dimensions are given for these additional cherubim in Solomon's Temple. Since the plan for the Temple was given to David by God (I Chronicles 28:11, 19), that could be a clue as to the proportions of the bodies to the wing span.

12. Some people actually saw cherubim (Adam and Eve, Ezekiel, John) and depictions of them were made at God's command, with actual plans given by God (the Tabernacle, the Ark of the Covenant, and Solomon's Temple; see I Chronicles 28:11, 19). Down through Jewish history, cherubim were not depicted as having literal eyes covering their bodies.

13. Sometimes these beings have been illustrated as though they each had four heads; however, both John and Ezekiel use the word *face* and not the word *head.* The Hebrew word for *face* is the same word that is used in "the face of the earth" (Ezekiel 38:20), and "the face of the porch" (Ezekiel 41:25 KJV). The Greek word for *face* can mean *the surface.*

Examining information about cherubim from other parts of the Bible helps clarify what these faces were like. The bodies (nor the wheels) evidently do not turn, but the heads can turn. In the NASB, the following verse has the words *their faces* in italics. When we look at the passage in Ezekiel 10:11, we see the phrase "whither the head looked." This indicates that each head had one primary front.

… As for the faces and wings of the four of them, their wings touched one another; their faces did not turn when they moved, each went straight forward. …And each went straight forward; wherever the spirit was about to go, they would go, without turning as they went. Ezekiel 1:8, 12

When they went, they went upon their four sides; they turned not as they went, but to the place whither the head looked they followed it; they turned not as they went.

Ezekiel 10:11 (KJV)

In addition, Moses was given specific instructions to see that the cherubim *face* each other and look down toward the mercy seat.

"The cherubim shall have their wings spread upward, covering the mercy seat with their wings and facing one another; the faces of the cherubim are to be turned toward the mercy seat." Exodus 25:20

This would again imply that there was really only one main front on each cherub's head. Ezekiel 41:18–19 presents some problems with this interpretation, however. Ezekiel tells us that when the temple walls were decorated with cherubim, in other words when they were seen in two dimensions, "every cherub had two faces."

It was carved with cherubim and palm trees; and a palm tree was between cherub and cherub, and every cherub had two faces, a man's face toward the palm tree on one side and a young lion's face toward the palm tree on the other side; they were carved on all the house all around.

Ezekiel 41:18–19

The only way this could agree with the above interpretation is if the heads were shown in a partially turned, three-quarter position, showing mostly the human part of the front turned toward the palm tree on one side of the palm tree. On the other

side, the lion part of the right side of the head was mostly visible. (The term *young lion* is one word in Hebrew and could still mean a lion with a mane.)

14. Ezekiel 1:8 might be saying that there were four hands for each cherub.

15. Underneath the throne is a firmament (*raqiya*), meaning *a pressed out solid*. The throne itself is described as being like sapphire.

 And above the firmament that was over their heads was the likeness of a throne, as the appearance of a sapphire stone. Ezekiel 1:26a (KJV)

 Then I looked, and, behold, in the firmament that was above the head of the cherubims there appeared over them as it were a sapphire stone, as the appearance of the likeness of a throne. Ezekiel 10:1 (KJV)

 And they saw the God of Israel: and there was under his feet as it were a paved work of a sapphire stone, and as it were the body of heaven in his clearness. Exodus 24:10 (KJV)

 It must be noted that most Bible resources agree that the gems that are named in the Scriptures are not necessarily the same as we know them today. We can only be certain if the context explains their appearance or designates their color. Therefore, since the same word translated *sapphire* in Exodus 24:10 is likened to something that is clear, both the throne and its platform are probably shining like a gemstone, but clear

16. Revelation 5:8.

BIBLIOGRAPHY

"Age of Pyramids", *National Geographic* (January 1995), 7.

Alcorn, Randy. *Heaven*. Carol Stream: Tyndale House Publishers, Inc., 2004.

Alexander, Ralph H. *Ezekiel*. Chicago: Moody Press, 1976.

"Ancient Greek Units of Measurement." http://www.en.wikipedia.org/wiki/Ancient_Greek_weights_and_ measures (2008).

Bailey, Kenneth E. *Jesus Through Middle Eastern Eyes.* Downers Grove: IVP Academic, 2008, 113–17.

Belz, Mindy. "Street Smart." *World,* 24:31, March 2007, 20–23.

Berry, George Ricker. *Interlinear Greek-English New Testament*. Grand Rapids: Baker Book House, 1977.

Brown, Dr. Walt. *In the Beginning*. Phoenix: Center for Scientific Creation, 2008, 365–66.

Brown, Francis, S. R. Driver, and C. A. Briggs, *A Hebrew and English Lexicon of the Old Testament*. NY: Oxford University Press, 1951, AB. Loc.

Bryant, Alton, ed. *The New Compact Bible Dictionary.* Grand Rapids: Zondervan, 1967, 275–81.

Currie, Susie. "Aging Peter Pans." *The Weekly Standard,* 5 Feb 2007, 32–34.

David Roberts, "Temples, History of Architectural Developments", *National Geographic* (January 1995), 15.

Dolphin, Lambert. "The Temple of Ezekiel." http://www.ldolphin.org/ezektmp.html (2008).

"Encyclopedia of World Biography—on Heron of Alexandria." http://www.bookrags.com/biography/hero-of-alexandria-wom/ (2008).

Fitzpatrick, Richard. "Euclid's Elements." http://farside.ph.utexas.edu/euclid.html (2008).

Fowler, David. "The Mathematics of Plato's Academy: A New Reconstruction (Second Edition)." http://www.maa.org/reviews/mpa.html (2008).

Gregg, Steve, ed. *Revelation: Four Views: A Parallel Commentary.* Nashville: Thomas Nelson Publishers, 1997, 478–505.

Grudem, Wayne. *Systematic Theology.* Grand Rapids: Zondervan, 1994, 1091–1165.

Hall, Christopher. "Christ's Kingdom and Paradise." *http://www.christianitytoday.com/ct/2003/november/24.79.html (2008).*

Halley, Henry H. *Halley's Bible Handbook, 24th edition.* Grand Rapids: Zondervan, 1965, 738–39.

"Heaven: The Invisible Realm." http://www.biblestudying.net (2008).

Hendrick, Dr. Gary. "Heaven on Earth." *Messianic Perspectives,* Jan/Feb 2009, Christian Jew Foundation.

Herodotus. *"The Hanging Gardens of Babylon."* http://www.plinia.net/wonders/gardens/hg4herodotus.html (2008).

Jeffrey, Grant R. *Heaven: The Mystery of Angels.* New Kesington, PA: Whitaker House, 1996.

Justin Martyr. *"The Apostolic Fathers with Justin Martyr and Irenaeus, chap. XXXV."* Christian Classics Ethereal Library, ANFO1. http://www.ccel.org/ccel/schaff/anf01.ix.vii.xxxvi.html (2008).

Kober, Manfred. *"The Millennial River."* http://www.middletownbiblechurch.org/proph/river.htm.

Larkin, Clarence. *The Book of Revelation.* New Rochelle: Rev. Clarence Larkin Estate, 1919, 32–43, 180–209.

Levy, David M. "Israel's Glorious Kingdom." *Israel My Glory,* Nov/Dec 2006, 34–35.

Louw, Johannes P., Eugene A. Nida. *Greek English Lexicon of the New Testament.* New York: United Bible Societies, 1989.

McClain, Alva J. *The Greatness of the Kingdom.* Winona Lake: BMH Books, 1974.

McKinney, B. B. *Broadman Hymnal.* Nashville: The Broadman Press, 1940.

Morgan, G. Campbell. *An Exposition of the Whole Bible.* Grand Rapids: Baker Book House, 1959, 361–65.

Morris, Henry M. "Biblical Eschatology and Modern Science, Part IV." *BibSac* 125:500 (October 1968): 292–99.

Pentecost, J. Dwight. "The Relation between Living and Resurrected Saints in the Millennium." *BibSac* 117:468 (October 1978): 332–40.

———. *Things to Come.* Grand Rapids: Zondervan, 508–510, 563–83.

Peterson, Dennis R. *Unlocking the Mysteries of Creation.* El Dorado: Creation Resource Publications, 2002, 176–227.

Price, Randall. *Jerusalem in Prophecy.* Eugene, Oregon: Harvest House Publishers, 1998, 303–321.

———. *The Temple and Bible Prophecy.* Eugene, Oregon: Harvest House Publishers, 2005.

Putnam, James. *Eyewitness Pyramid.* New York: DK Publishing, 2004.

Rosenthal, Marvin J. *"A New Heaven, a New Earth, a New Jerusalem We Didn't Even Know How to Dream!"* Zion's Fire, May/June 1993.

Scott, J. Julius Jr. *Jewish Backgrounds of the New Testament.* Grand Rapids: Baker Academic, 1995, 291 n. 37.

Sulley, Henry. *Ezekiel.* 1887, *http://tinyurl.com/4tjdaf6*

Sutter, Bill. *Israel My Glory.* May/June 2007, editorial.

Talmage, T. DeWitt. *The Gospel of the Pyramids,* sermon.

Tenney, Merrill C. *The Zondervan Pictorial Encyclopedia of the Bible, Vol. 2.* Grand Rapids: Zondervan, 1980, 466–68.

Thayer, Joseph. *Thayer's Greek-English Lexicon of the New Testament.* Grand Rapids: Zondervan Publishing House, 1956.

"The History of Measurement." http://www.en.wikipedia.org/wiki/history of measurement (2008).

The Temple Institute. "How Do We Understand the Vision of the Future Temple as Described in the Book of Ezekiel?" http://www.templeinstitute.org/future_temple.htm (2010).

Thomas, Robert L. "The Glorified Christ on Patmos." *BibSac* 122:487 (July 1965): 242–47.

Vincent, Marvin. *Word Studies in the New Testament*, Vol. 2. Peabody: Hendrickson Publishers, 1985, 440–41, 480–85, 565–70.

Walvoord, John F. "Doctrine of Millennium, Part III: Social and Economic Aspects of Millennium." *BibSac* 114:459 (July 1958): 200.

———. *"Doctrine of Millennium, Part IV: The Heavenly Jerusalem."* *BibSac* 115:460 (October 1958): 291.

———. *Prophecy.* Nashville: Thomas Nelson, 1993, 168–75.

———. *The Revelation of Jesus Christ.* Chicago: Moody Press, 1966, 316–29.

Walvoord, John F. and Roy B. Zuck. *The Bible Knowledge Commentary, New Testament.* Wheaton: Victor Books, 1983, 986–87.

Wesley, John. "Explanatory Notes on the Whole Bible." http://www.searchgodsword.org/com/wen/view.cgi?book=re&chapter=020 (2008).

Whitcomb, Dr. John C. "The Millennial Temple of Ezekiel 40–48." *http://www.middletownbible church.org/proph/templemi.html* (2008).

Wiersbe, Warren. *The Bible Exposition Commentary.* Wheaton: Victor Books, 1989, 622–25.

Wigram, George, V. *The Englishman's Greek Concordance of the New Testament*. Peabody: Hendrickson Publishers, 1996.

———. *The Englishman's Hebrew and Chaldee Concordance of the Old Testament*. Grand Rapids: Baker Book House, 1980.

Willmington, Dr. H. L. *Willmington's Guide to the Bible, Vol. I*. Wheaton: Tyndale House Publishers, Inc., 1986, 223–24.

Wise, Michael, Martin Abegg Jr., and Edward Cook. *The Dead Sea Scrolls: A New Translation*. New York: HarperOne, 2005, 1–45, 557–63.

You can visit the Author/Illustrator, Janet Willis on her website:
www.whatonearthisheavenlike.com